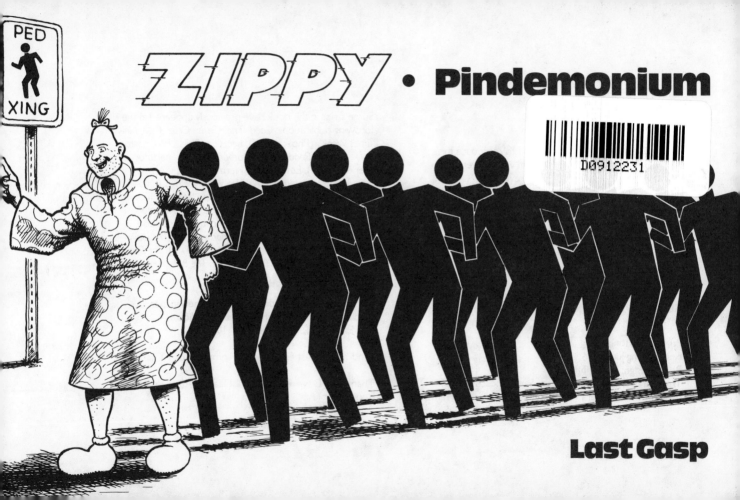

Published and distributed by: Last Gasp, Inc.
2180 Bryant St.
San Francisco, CA 94110

Library of Congress Catalogue Card Number: 86-81944

ISBN: 0-86719-348-4

Printed in Hong Kong
First printing June 1986
Book Design: Bill Griffith
Typography: Ampersand Design, San Francisco
Negatives and Camera Work: G. Howard, Inc., San Francisco

Some strips in this book have previously appeared in the following publications: *Good Times* (Santa Cruz, CA), *New Times Weekly* (Phoenix, AZ), *Real Fun* (Phila., PA), *Boston Rock, Chicago Reader, Santa Barbara Weekly, Spectator* (Berkeley, CA), *Easy Reader* (Hermosa Bch., CA), *Aardvark* (Sacramento, CA), *Noe Valley Voice* (S.F., CA), *Columbus Free Press* (OH), *Arizona Daily Wildcat* (Tucson), *Atlantic Sun* (Boca Raton, FL), *The Columbia Spectator* (N.Y., N.Y.), *Detroit Metro Times, Montage* (Kirkwood, MO), *San Jose Metro, Univ. of Anchorage Voice, The Daily Maine Campus, Illini Chronicle* (Champagne, IL), *The San Francisco Examiner, The Boston Globe, The Baltimore Evening Sun* and *The Shreveport Journal.*

For information regarding ZIPPY *daily* newspaper syndication, contact: King Features Syndicate, 235 E. 45th St., New York, NY 10017.

Send 1.00 to Last Gasp, Inc. for complete ZIPPY catalogue.

Thanks to Dave Burgin, Will Hearst, Allan Priaulx and Ron Turner.

"FOUR PANEL AFFAIR"

BILL GRIFFITH

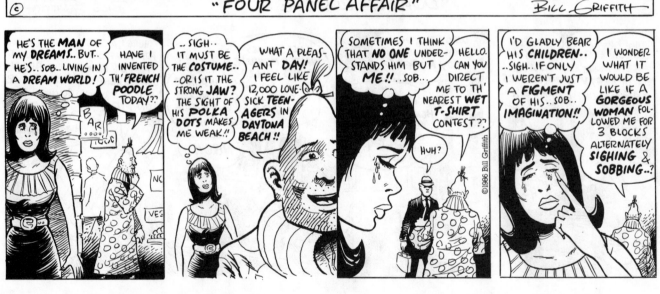

©1986 Bill Griffith

"OOH, LA ROUCHE!!"

BILL GRIFFITH

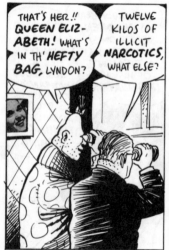

THAT'S HER!! QUEEN ELIZABETH! WHAT'S IN TH' HEFTY BAG, LYNDON?

TWELVE KILOS OF ILLICIT NARCOTICS, WHAT ELSE?

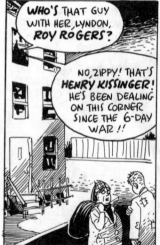

WHO'S THAT GUY WITH HER, LYNDON, ROY ROGERS?

NO, ZIPPY! THAT'S HENRY KISSINGER! HE'S BEEN DEALING ON THIS CORNER SINCE THE 6-DAY WAR!!

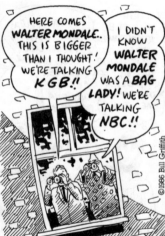

HERE COMES WALTER MONDALE.. THIS IS BIGGER THAN I THOUGHT! WE'RE TALKING KGB!!

I DIDN'T KNOW WALTER MONDALE WAS A BAG LADY! WE'RE TALKING NBC!!

©1986 Bill Griffith

THERE'S A CALL FOR YOU FROM TH'POPE!! BRUCE SPRINGSTEEN'S ON LINE 3!! WHO'S ON FIRST?

TAKE A MESSAGE! I JUST SAW ADLAI STEVENSON JR. SELLING SURFACE TO AIR MISSILES TO ENGLEBERT HUMPERDINCK!!

ZiPPy

"FUTURE IMPERFECT"

BILL GRIFFITH

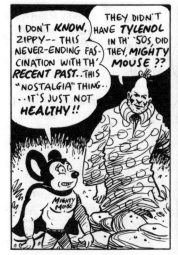

I DON'T *KNOW*, ZIPPY-- THIS NEVER-ENDING FASCINATION WITH TH' *RECENT PAST*.. THIS "*NOSTALGIA*" THING... ...IT'S JUST NOT *HEALTHY*!!

THEY DIDN'T HAVE *TYLENOL* IN TH' '50s, DID THEY, *MIGHTY MOUSE*??

MIGHTY MOUSE

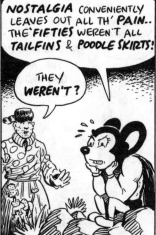

NOSTALGIA CONVENIENTLY LEAVES OUT ALL TH' *PAIN*.. THE *FIFTIES* WEREN'T ALL *TAILFINS* & *POODLE SKIRTS*!

THEY *WEREN'T*?

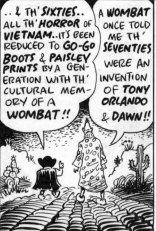

..& TH' *SIXTIES*.. ALL TH' *HORROR* OF *VIETNAM*...IT'S BEEN REDUCED TO *GO-GO BOOTS* & *PAISLEY PRINTS* BY A GENERATION WITH TH' CULTURAL MEMORY OF A *WOMBAT*!!

A *WOMBAT* ONCE TOLD ME TH' *SEVENTIES* WERE AN INVENTION OF *TONY ORLANDO* & *DAWN*!!

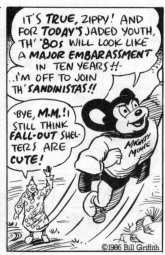

IT'S *TRUE*, ZIPPY! AND FOR *TODAY'S* JADED YOUTH, TH' '80s WILL LOOK LIKE A *MAJOR EMBARRASSMENT* IN TEN YEARS!! ...I'M OFF TO JOIN TH' *SANDINISTAS*!!

'BYE, *M.M.*! I STILL THINK *FALL-OUT SHELTERS* ARE *CUTE*!

MIGHTY MOUSE

©1986 Bill Griffith

"PEOPLE WHO NEED PEOPLE"

BILL GRIFFITH

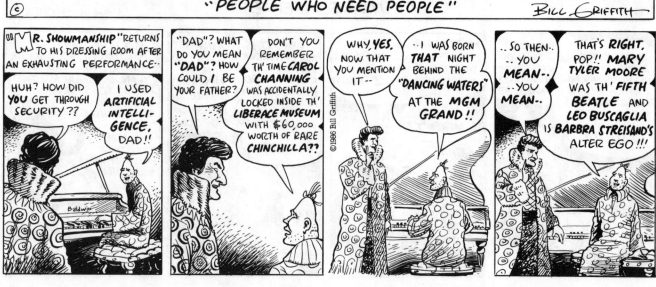

"MR. SHOWMANSHIP" RETURNS TO HIS DRESSING ROOM AFTER AN EXHAUSTING PERFORMANCE..

HUH? HOW DID YOU GET THROUGH SECURITY??

I USED ARTIFICIAL INTELLIGENCE, DAD!!

"DAD"? WHAT DO YOU MEAN "DAD"? HOW COULD I BE YOUR FATHER?

DON'T YOU REMEMBER TH' TIME CAROL CHANNING WAS ACCIDENTALLY LOCKED INSIDE TH' LIBERACE MUSEUM WITH $60,000 WORTH OF RARE CHINCHILLA??

©1986 Bill Griffith

WHY, YES, NOW THAT YOU MENTION IT--

..I WAS BORN THAT NIGHT BEHIND THE "DANCING WATERS" AT THE MGM GRAND!!

.. SO THEN.. ..YOU MEAN.. ..YOU MEAN..

THAT'S RIGHT, POP!! MARY TYLER MOORE WAS TH' FIFTH BEATLE AND LEO BUSCAGLIA IS BARBRA STREISAND'S ALTER EGO!!!

"THE ROCK 'N ROLLIZATION OF EVERYTHING"

BILL GRIFFITH

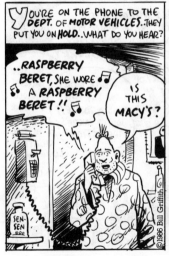

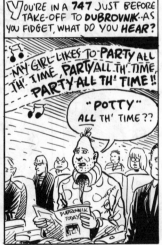

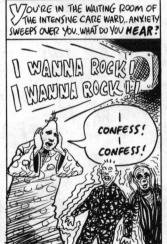

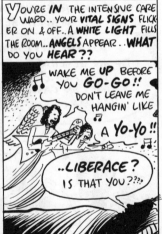

Z i P p y

"YOWL"

BILL GRIFFITH

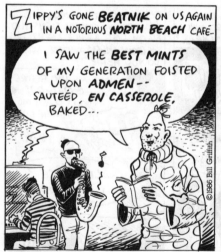

ZIPPY'S GONE **BEATNIK** ON US AGAIN IN A NOTORIOUS **NORTH BEACH** CAFÉ..

I SAW THE **BEST MINTS** OF MY GENERATION FOISTED UPON **ADMEN** -- SAUTÉED, *EN CASSEROLE*, BAKED...

© 1996 Bill Griffith

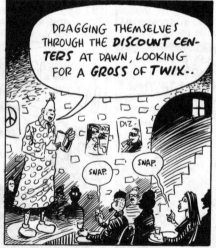

DRAGGING THEMSELVES THROUGH THE **DISCOUNT CENTERS** AT DAWN, LOOKING FOR A **GROSS** OF **TWIX**..

BIRD DIZ

SNAP. SNAP.

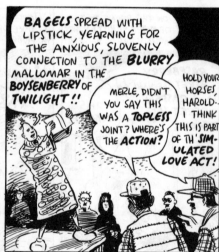

BAGELS SPREAD WITH LIPSTICK, YEARNING FOR THE **ANXIOUS**, SLOVENLY CONNECTION TO THE **BLURRY** MALLOMAR IN THE **BOYSENBERRY** OF **TWILIGHT !!**

MERLE, DIDN'T YOU SAY THIS WAS A **TOPLESS** JOINT? WHERE'S THE **ACTION?**

HOLD YOUR HORSES, HAROLD.. I THINK THIS IS PART OF TH' **SIMULATED LOVE ACT!**

"ARTISTIC CONTROL"

BILL GRIFFITH

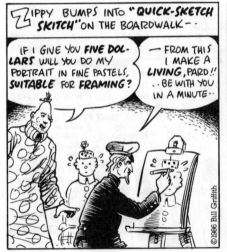

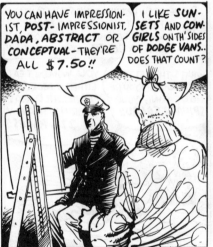

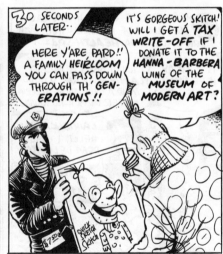

"STARHOUND I"

BILL GRIFFITH

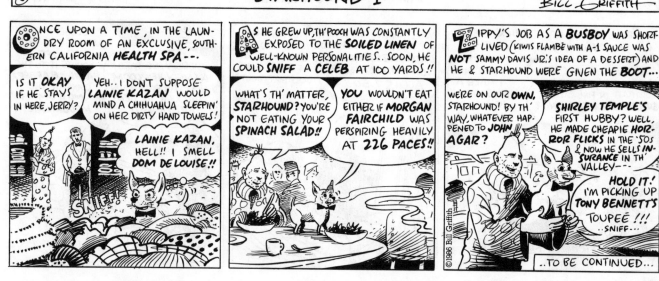

ONCE UPON A TIME, IN THE LAUNDRY ROOM OF AN EXCLUSIVE, SOUTHERN CALIFORNIA **HEALTH SPA**---

IS IT **OKAY** IF HE STAYS IN HERE, JERRY?

YEH..I DON'T SUPPOSE **LAINIE KAZAN** WOULD MIND A CHIHUAHUA SLEEPIN' ON HER DIRTY HAND TOWELS!

LAINIE KAZAN, HELL!! I SMELL **DOM DE LOUISE!!**

SNIFF!

AS HE GREW UP, TH' POOCH WAS CONSTANTLY EXPOSED TO THE **SOILED LINEN** OF WELL-KNOWN PERSONALITIES.. SOON, HE COULD **SNIFF** A **CELEB** AT 100 YARDS!!

WHAT'S TH' MATTER, **STARHOUND?** YOU'RE NOT EATING YOUR **SPINACH SALAD!!**

YOU WOULDN'T EAT EITHER IF **MORGAN FAIRCHILD** WAS PERSPIRING HEAVILY AT **226 PACES!!**

ZIPPY'S JOB AS A **BUSBOY** WAS SHORT-LIVED (KIWIS FLAMBÉ WITH A-1 SAUCE WAS **NOT** SAMMY DAVIS JR.'S IDEA OF A DESSERT) AND HE & STARHOUND WERE GIVEN THE **BOOT**...

WE'RE ON OUR **OWN,** STARHOUND! BY TH' WAY, WHATEVER HAPPENED TO **JOHN AGAR?**

SHIRLEY TEMPLE'S FIRST HUBBY? WELL, HE MADE CHEAPIE **HORROR FLICKS** IN THE '50S & NOW HE SELLS **INSURANCE** IN TH' VALLEY---

HOLD IT! I'M PICKING UP **TONY BENNETT'S TOUPEE !!!** ..SNIFF..

..TO BE CONTINUED...

"STARHOUND II"

BILL GRIFFITH

Panel 1:
STARHOUND'S UNCANNY ABILITY TO **SNIFF** OUT **CELEBS** GIVES ZIPPY AN ACTUAL IDEA..

GO ON, **ASK** HIM!

TONY, THE **WIG** IS **HUGE**, BUT WHAT D'YOU THINK ABOUT THE "**BUB-BLE THEORY**" OF TH' **UNIVERSE**? WAS **EINSTEIN** ALL WET OR WHAT?

YOU'RE BEAUTIFUL, DUDE, **NEVER** CHANGE!

Panel 2:
..TONY WAS RATHER **CRYPTIC**.. ..MAYBE WE'LL GET A **CLEARER** RE-SPONSE FROMSNIFF.. FROM.. **EARL** "**MAD-MAN**" **MUNTZ**!!

THE USED CAR KING WHO SOLD MILLIONS OF "**ONE-KNOB**" **TVS** IN THE **FIFTIES**?! **YOW**!!

LATER, DUDE..

SNIFF SNIFF!

©1986 Bill Griffith

Panel 3:
SO, **EARL**..WHAT ABOUT THIS **BUBBLE THEORY** OF THE UNIVERSE? IS IT **VIABLE**, OR WHAT??

"**VIABLE**" DOESN'T PUT **STEAK** ON TH' TABLE, STAR-POOCH! 'ADD A LITTLE **CHROME** & A FEW **RACING STRIPES** & I GUARANTEE $20 **BILLION** IN SALES BY TH' NEXT **ICE AGE**!!

Panel 4:
THE INQUISITIVE **PUP** NEXT QUERIES MTV'S **VEE-JAYS**..

SO, **LISA**, HOW HAS THIS NEW POSTULATION AFFECTED **YOUR** LIFESTYLE?

DID IT **BURST** YET?

PROGRAMMING? SET ASIDE **FOURTEEN** MIN-UTES NEXT TUES-DAY..WE'RE DOING A "**BUBBLE-AID**" BENEFIT.. YEH, THIS TIME IT'S TH' WHOLE **COSMOS**...

PERPET-UALLY PERT.

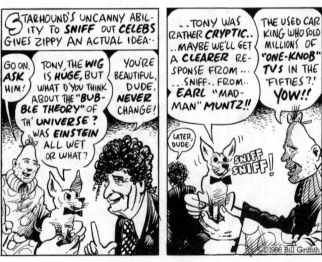
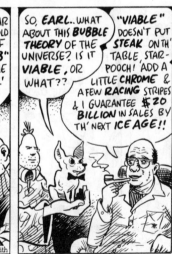
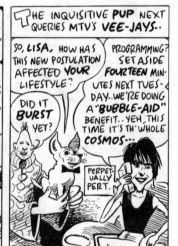

Z i P p y

"STARHOUND III"

BILL GRIFFITH

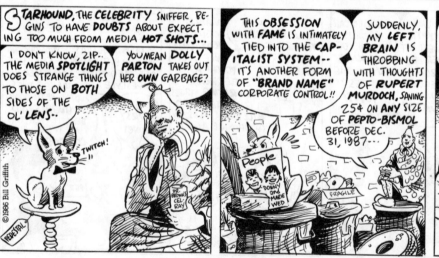

STARHOUND, THE CELEBRITY SNIFFER, BEGINS TO HAVE DOUBTS ABOUT EXPECTING TOO MUCH FROM MEDIA HOT SHOTS...

I DON'T KNOW, ZIP.. THE MEDIA SPOTLIGHT DOES STRANGE THINGS TO THOSE ON BOTH SIDES OF THE OL' LENS..

YOU MEAN DOLLY PARTON TAKES OUT HER OWN GARBAGE?

"TWITCH!"

DR. BROWN'S CEL RAY

© 1986 Bill Griffith

PEDESTAL

THIS OBSESSION WITH FAME IS INTIMATELY TIED INTO THE CAPITALIST SYSTEM-- IT'S ANOTHER FORM OF "BRAND NAME" CORPORATE CONTROL!!

SUDDENLY, MY LEFT BRAIN IS THROBBING WITH THOUGHTS OF RUPERT MURDOCH, SAVING 25¢ ON ANY SIZE OF PEPTO-BISMOL BEFORE DEC. 31, 1987...

People

DONNY AND MARIE WED

FRAGILE

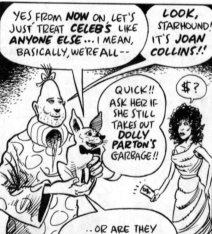

YES, FROM NOW ON, LET'S JUST TREAT CELEB'S LIKE ANYONE ELSE ... I MEAN, BASICALLY, WE'RE ALL--

LOOK, STARHOUND! IT'S JOAN COLLINS!!

QUICK!! ASK HER IF SHE STILL TAKES OUT DOLLY PARTON'S GARBAGE!!

$?

..OR ARE THEY JUST GOOD FRIENDS..?

"TREND-O-RAMA"

BILL GRIFFITH

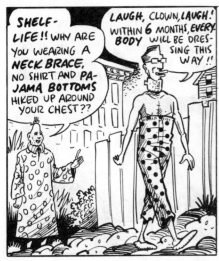

SHELF-LIFE!! WHY ARE YOU WEARING A NECK BRACE, NO SHIRT AND PAJAMA BOTTOMS HIKED UP AROUND YOUR CHEST??

LAUGH, CLOWN, LAUGH! WITHIN 6 MONTHS, EVERYBODY WILL BE DRESSING THIS WAY!!

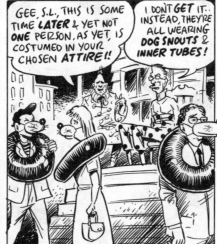

GEE, S.L., THIS IS SOME TIME LATER & YET NOT ONE PERSON, AS YET, IS COSTUMED IN YOUR CHOSEN ATTIRE!!

I DON'T GET IT.. INSTEAD, THEY'RE ALL WEARING DOG SNOUTS & INNER TUBES!

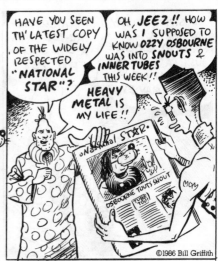

HAVE YOU SEEN TH' LATEST COPY OF THE WIDELY RESPECTED "NATIONAL STAR"?

HEAVY METAL IS MY LIFE!!

OH, JEEZ!! HOW WAS I SUPPOSED TO KNOW OZZY OSBOURNE WAS INTO SNOUTS & INNER TUBES THIS WEEK!!

National STAR
OSBOURNE TOUTS SNOUT
TUBE TOO!
MOM

©1986 Bill Griffith

"SOCKS THERAPY"

BILL GRIFFITH

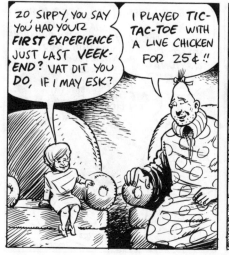

ZO, SIPPY, YOU SAY YOU HAD YOUR *FIRST EXPERIENCE* JUST LAST *VEEKEND*? VAT DIT YOU DO, IF I MAY ESK?

I PLAYED *TIC-TAC-TOE* WITH A LIVE CHICKEN FOR 25¢!!

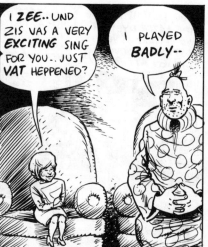

I *ZEE*.. UND ZIS VAS A VERY *EXCITING* SING FOR YOU.. JUST VAT HEPPENED?

I PLAYED *BADLY*--

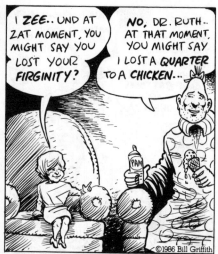

I *ZEE*.. UND AT ZAT MOMENT, YOU MIGHT SAY YOU LOST YOUR *FIRGINITY*?

NO, DR. RUTH.. AT THAT MOMENT, YOU MIGHT SAY I LOST A *QUARTER* TO A *CHICKEN*..

©1986 Bill Griffith

Z i P p y

"MOVING VIOLATION"

BILL GRIFFITH

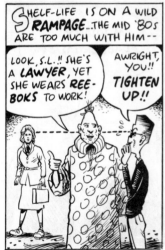

SHELF-LIFE IS ON A WILD RAMPAGE...THE MID '80s ARE TOO MUCH WITH HIM--

LOOK, S.L.!! SHE'S A *LAWYER,* YET SHE WEARS *REEBOKS* TO WORK!

AWRIGHT, YOU!! *TIGHTEN UP!!*

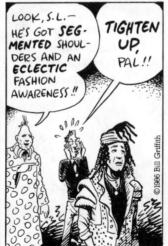

LOOK, S.L.— HE'S GOT *SEGMENTED* SHOULDERS AND AN *ECLECTIC* FASHION AWARENESS!!

TIGHTEN UP, PAL!!

©1986 Bill Griffith

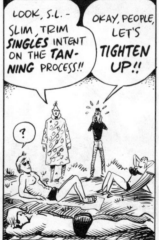

LOOK, S.L.— *SLIM, TRIM SINGLES* INTENT ON THE *TANNING* PROCESS!!

OKAY, PEOPLE, LET'S *TIGHTEN UP!!*

?

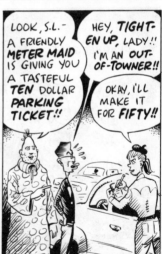

LOOK, S.L.— A FRIENDLY *METER MAID* IS GIVING YOU A TASTEFUL *TEN* DOLLAR *PARKING TICKET!!*

HEY, *TIGHTEN UP,* LADY!! I'M AN *OUT-OF-TOWNER!!*

OKAY, I'LL MAKE IT FOR *FIFTY!!*

"ALMOST LIKE PRAYING"

BILL GRIFFITH

"STREET TALKER"

BILL GRIFFITH

"NANCY and SLOGAN"

BILL GRIFFITH

ZIPPY HIKES DEEP INTO "BUSHMILLER COUNTRY"--

!

THREE ROCKS!!

HAVE YOU NOTICED, THESE DAYS, ZIPPY? YOU'RE **NOTHING** WITHOUT A **MOTTO** OR A **CATCH PHRASE!**

THAT'S **RIGHT**, NANCY!! **MY** CORPORATE IMAGE IS **SHIFTING** IMPERCEPTIBLY AS WE SPEAK!!

WHAT DO YOU THINK OF "**LIFE** BEGINS AT **THIRTEEN**"? IT HAS A **LILT** TO IT---

I THINK THAT ONE'S ALREADY TAKEN BY TH' FAMED **THOMPSON TWINS**!!

© 1985 Bill Griffith

HEY, **WAIT** A MINUTE !! WHAT AM I **TALKING** ABOUT?! I DON'T NEED A **GIMMICK**, I'M **ME**! NANCY!! I'M AN AMERICAN INSTITUTION !!

THAT ONE'S A LITTLE TOO **LONG**, NANCY.. HOW ABOUT "LOVE ME, LOVE MY **HAIR**"?

ZiPPy

"MENTAL DETECTOR"

BILL GRIFFITH

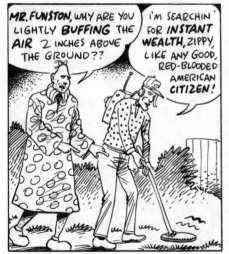

MR. FUNSTON, WHY ARE YOU LIGHTLY **BUFFING** THE AIR 2 INCHES ABOVE THE GROUND??

I'M SEARCHIN' FOR **INSTANT WEALTH**, ZIPPY, LIKE ANY GOOD, RED-BLOODED AMERICAN **CITIZEN**!

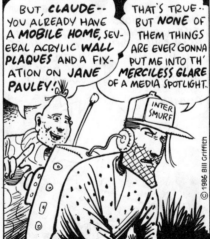

BUT, **CLAUDE** -- YOU ALREADY HAVE A **MOBILE HOME**, SEVERAL ACRYLIC **WALL PLAQUES** AND A FIXATION ON **JANE PAULEY**!

THAT'S TRUE.. BUT **NONE** OF THEM THINGS ARE EVER GONNA PUT ME INTO TH' **MERCILESS GLARE** OF A MEDIA SPOTLIGHT.

INTER SMURF

© 1986 Bill Griffith

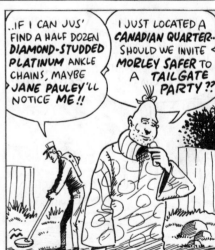

..IF I CAN JUS' FIND A HALF DOZEN **DIAMOND-STUDDED PLATINUM** ANKLE CHAINS, MAYBE JANE PAULEY'LL NOTICE **ME**!!

I JUST LOCATED A **CANADIAN QUARTER** -- SHOULD WE INVITE **MORLEY SAFER** TO A **TAILGATE PARTY**??

"SERENITY TO GO"

BILL GRIFFITH

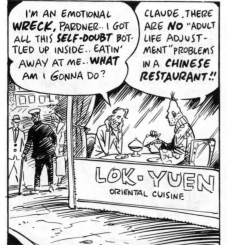

I'M AN EMOTIONAL **WRECK**, PARDNER.. I GOT ALL THIS **SELF-DOUBT** BOTTLED UP INSIDE.. EATIN' AWAY AT ME.. **WHAT** AM I GONNA DO?

CLAUDE, THERE ARE **NO** "ADULT LIFE ADJUSTMENT" PROBLEMS IN A **CHINESE RESTAURANT**!!

LOK-YUEN
ORIENTAL CUISINE

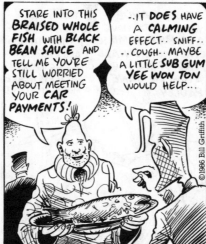

STARE INTO THIS **BRAISED WHOLE FISH** WITH **BLACK BEAN SAUCE** AND TELL ME YOU'RE STILL WORRIED ABOUT MEETING YOUR **CAR PAYMENTS**!

..IT **DOES** HAVE A **CALMING** EFFECT.. SNIFF.. ..COUGH.. MAYBE A LITTLE **SUB GUM YEE WON TON** WOULD HELP...

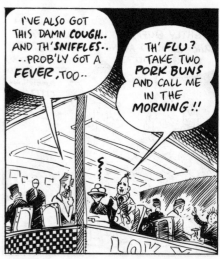

I'VE ALSO GOT THIS DAMN **COUGH**.. AND TH' **SNIFFLES**.. ..PROB'LY GOT A **FEVER**, TOO..

TH' **FLU**? TAKE TWO **PORK BUNS** AND CALL ME IN THE **MORNING** !!

©1996 Bill Griffith

ZiPPy

"NOT SO QUIET STORM"

Bill Griffith

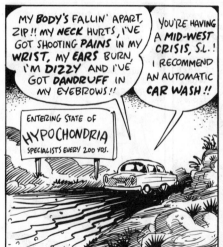

MY **BODY'S** FALLIN' APART, ZIP!! MY **NECK** HURTS, I'VE GOT SHOOTING **PAINS** IN MY **WRIST**, MY **EARS** BURN, I'M **DIZZY** AND I'VE GOT **DANDRUFF** IN MY EYEBROWS!!

YOU'RE HAVING A **MID-WEST CRISIS**, S.L.! I RECOMMEND AN AUTOMATIC **CAR WASH**!!

ENTERING STATE OF **HYPOCHONDRIA** SPECIALISTS EVERY 2.00 YDS.

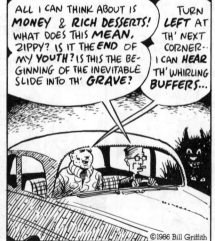

ALL I CAN THINK ABOUT IS **MONEY** & **RICH DESSERTS**! WHAT DOES THIS **MEAN**, ZIPPY? IS IT THE **END** OF MY **YOUTH**? IS THIS THE BEGINNING OF THE INEVITABLE SLIDE INTO TH' **GRAVE**?

TURN LEFT AT TH' NEXT CORNER-- I CAN **HEAR** TH' WHIRLING **BUFFERS**...

©1986 Bill Griffith

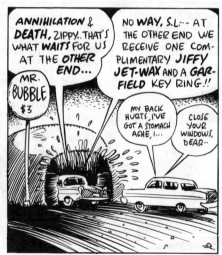

ANNIHILATION & **DEATH**, ZIPPY.. THAT'S WHAT **WAITS** FOR US AT THE **OTHER END**...

MR. BUBBLE $3

NO **WAY**, S.L.-- AT THE OTHER END WE RECEIVE ONE COMPLIMENTARY **JIFFY JET-WAX** AND A **GARFIELD** KEY RING!!

MY **BACK** HURTS, I'VE GOT A **STOMACH** ACHE, I...

CLOSE YOUR WINDOWS, DEAR..

"CLOUD 9½" BILL GRIFFITH

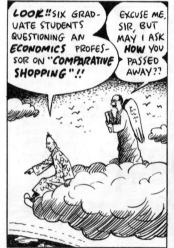

LOOK!! SIX GRADUATE STUDENTS QUESTIONING AN ECONOMICS PROFESSOR ON "COMPARATIVE SHOPPING"!!

EXCUSE ME, SIR, BUT MAY I ASK HOW YOU PASSED AWAY??

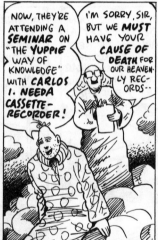

NOW, THEY'RE ATTENDING A SEMINAR ON "THE YUPPIE WAY OF KNOWLEDGE" WITH CARLOS I. NEEDA CASSETTE-RECORDER!

I'M SORRY, SIR, BUT WE MUST HAVE YOUR CAUSE OF DEATH FOR OUR HEAVENLY RECORDS...

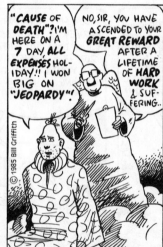

"CAUSE OF DEATH"? I'M HERE ON A 7 DAY, ALL EXPENSES HOLIDAY!! I WON BIG ON "JEOPARDY"!

NO, SIR, YOU HAVE ASCENDED TO YOUR GREAT REWARD AFTER A LIFETIME OF HARD WORK & SUFFERING..

© 1985 Bill Griffith

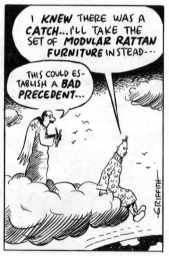

I KNEW THERE WAS A CATCH... I'LL TAKE THE SET OF MODULAR RATTAN FURNITURE INSTEAD---

THIS COULD ESTABLISH A BAD PRECEDENT...

"MEDICINAL PURPOSES"

BILL GRIFFITH

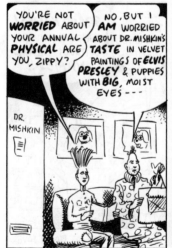

YOU'RE NOT **WORRIED** ABOUT YOUR ANNUAL **PHYSICAL** ARE YOU, ZIPPY?

NO, BUT I **AM** WORRIED ABOUT DR. MISHKIN'S **TASTE** IN VELVET PAINTINGS OF **ELVIS PRESLEY** & PUPPIES WITH **BIG**, MOIST EYES ---

DR. MISHKIN

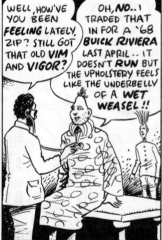

WELL, HOW'VE YOU BEEN **FEELING** LATELY, ZIP? STILL GOT THAT OLD **VIM** AND **VIGOR?**

OH, **NO**.. I TRADED THAT IN FOR A '68 **BUICK RIVIERA** LAST APRIL .. IT DOESN'T **RUN** BUT THE UPHOLSTERY FEELS LIKE THE UNDERBELLY OF A **WET WEASEL!!**

I **SEE**.. CAN YOU SAY "**WET WEASEL**" AGAIN, PLEASE ... AND THEN TAKE A NICE, DEEP BREATH--

IS THIS ANOTHER ADVANCE IN **MODERN MEDICINE?**

© 1985 Bill Griffith

LATER, AFTER A SERIES OF EX-**TENSIVE** TESTS--

ZIPPY, I'M SORRY TO HAVE TO TELL YOU THIS.. BUT THE **RESULTS** SHOW YOU HAVE NO MORE THAN **ONE WEEK** TO **LIVE**..I'M REALLY VERY...

OH MY GOD ...

...DOC, WOULD YOU LIKE TO **BUY** TWO TICKETS TO NEXT THURSDAY'S **AC/DC** CONCERT?

--- **T**O BE **CONTINUED!!**

Z i P p y

"LIFE IS A MAGAZINE"

BILL GRIFFITH

Panel 1:
ZIPPY'S BEEN GIVEN **ONE WEEK TO LIVE**.. HE NEEDS TO **RE-ORDER** HIS **PRIORITIES**..

...I ALSO HAVE TO RE-ORDER MY BLOWN-GLASS **POODLE** COLLECTION!

IT'S SO **SAD**.. HE'S ONLY **14**..OR MAYBE **45**--

© 1985 Bill Griffith

Panel 2:
ZIPPY, IF I WERE YOU, I'D WANT TO VISIT A PLEASANT, **NATURAL** SURROUNDING AND MAKE **PEACE** WITH MY **INNER BEING**..

THAT'S **AMAZING!** HOW DID YOU KNOW THERE WAS A SALE ON **VELCRO FASTENERS** AT "BEAUTIFUL BOB'S **DISCOUNT VILLAGE**"?

Panel 3:
LISTEN, PERHAPS IT'D BE BETTER IF YOU JUST SPENT THE **WHOLE WEEK** AT A HOUSE OF **ILL REPUTE**, INDULGING IN COMPLETE SENSUAL **GRATIFICATION**--

NOW YOU'RE TALKING!! THERE'S AN ENORMOUS **WALGREEN'S** ABOUT TWO BLOCKS FROM HERE!!

Panel 4:
WELL, IF **THIS** IS WHAT YOU WANT--

BRAND NAMES! WE'RE NOTHING WITHOUT **BRAND NAMES!!**

ORTHOPEDIC HOSIERY

DENTURE CLEANSERS

NEXT: RAPTURE AT PAY 'N' SAVE..

"WAY TO GO"

BILL GRIFFITH

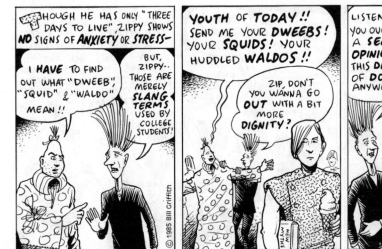

THOUGH HE HAS ONLY "THREE DAYS TO LIVE", ZIPPY SHOWS **NO** SIGNS OF **ANXIETY** OR **STRESS**—

I **HAVE** TO FIND OUT WHAT "DWEEB", "SQUID" & "WALDO" MEAN !!

BUT, ZIPPY.. THOSE ARE MERELY **SLANG TERMS** USED BY COLLEGE STUDENTS!

YOUTH OF **TODAY** !! SEND ME YOUR **DWEEBS**! YOUR **SQUIDS**! YOUR HUDDLED **WALDOS** !!

ZIP, DON'T YOU WANNA GO **OUT** WITH A BIT MORE **DIGNITY** ?

© 1985 Bill Griffith

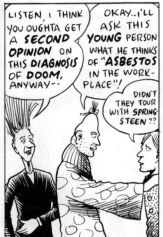

LISTEN, I THINK YOU OUGHTA GET A **SECOND OPINION** ON THIS **DIAGNOSIS** OF **DOOM,** ANYWAY--

OKAY..I'LL ASK THIS **YOUNG** PERSON WHAT HE THINKS OF "**ASBESTOS** IN THE WORK-PLACE"!

DIDN'T THEY TOUR WITH **SPRING-STEEN** ??

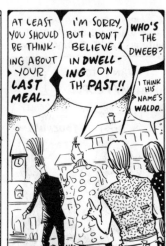

AT LEAST YOU SHOULD BE THINK-ING ABOUT YOUR **LAST MEAL**..

I'M SORRY, BUT I DON'T BELIEVE IN **DWELL-ING** ON TH' **PAST** !!

WHO'S THE DWEEB?

I THINK HIS NAME'S WALDO..

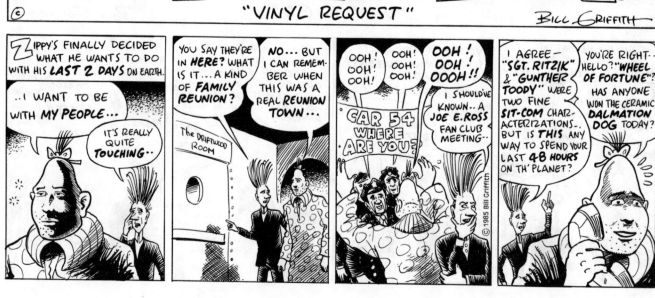

"ONE MORE SPIN"

BILL GRIFFITH

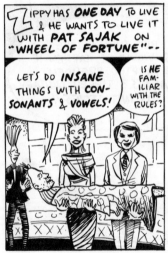

ZIPPY HAS **ONE DAY** TO LIVE & HE WANTS TO LIVE IT WITH **PAT SAJAK** ON "**WHEEL OF FORTUNE**"--

LET'S DO **INSANE** THINGS WITH CON-SONANTS & VOWELS!

IS HE FAM-ILIAR WITH THE RULES?

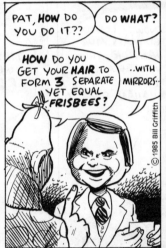

PAT, **HOW** DO YOU DO IT??

DO **WHAT**?

HOW DO YOU GET YOUR **HAIR** TO FORM **3** SEPARATE YET EQUAL **FRISBEES**?

..WITH MIRRORS..

© 1985 Bill Griffith

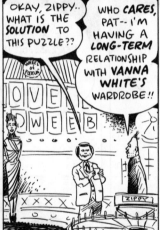

OKAY, ZIPPY.. WHAT IS THE **SOLUTION** TO THIS PUZZLE??

WHO **CARES**, PAT-- I'M HAVING A **LONG-TERM** RELATIONSHIP WITH **VANNA WHITE'S** WARDROBE!!

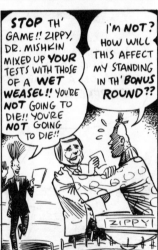

STOP TH' GAME!! ZIPPY, DR. MISHKIN MIXED UP **YOUR** TESTS WITH THOSE OF A **WET WEASEL**!! YOU'RE **NOT** GOING TO DIE!! YOU'RE **NOT** GOING TO DIE!!

I'M **NOT**? HOW WILL THIS AFFECT MY STANDING IN TH' **BONUS ROUND**??

Z i P p y

"MILK OF AMNESIA"

BILL GRIFFITH

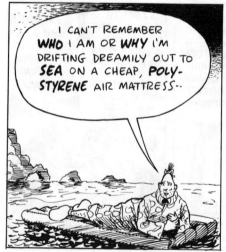

I CAN'T REMEMBER **WHO** I AM OR **WHY** I'M DRIFTING DREAMILY OUT TO **SEA** ON A CHEAP, **POLYSTYRENE** AIR MATTRESS--

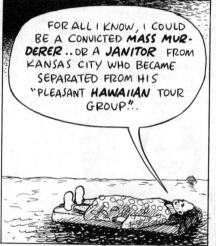

FOR ALL I KNOW, I COULD BE A CONVICTED **MASS MURDERER**..OR A **JANITOR** FROM KANSAS CITY WHO BECAME SEPARATED FROM HIS "PLEASANT **HAWAIIAN** TOUR GROUP."

..I BET THINGS LIKE **THIS** WOULDN'T HAPPEN IF WE ADOPTED PRESIDENT **REAGAN'S** 3-TIERED, **UNITARY TAX INITIATIVES !!**

"S.S. FORT BAXTER"

BILL GRIFFITH

I'M *ADRIFT* ON A CHEAP, POLYSTYRENE *AIR MATTRESS* AGAIN.. ..BUT *THIS* TIME, I'M WITH THE LATE *PAUL FORD*..

THAT'S ME, "*COL. HALL*" ON THE OLD "*BILKO*" SHOW.. ..I WAS THE *PERFECT PATSY* FOR FAST-TALKING *PHIL SILVERS!!*

* R.I.P. SARGE.. (1912-1985)

© 1986 Bill Griffith

COLONEL, I'M AFRAID YOU'LL HAVE TO *EXCUSE* ME FROM MANEUVERS THIS WEEK.. MY POOR *UNCLE FELIX* HAS FALLEN ILL & I *MUST* BE BY HIS SIDE..

..*UNCLE FELIX?* I THOUGHT HE SUCCUMBED TO "*FLANGE FOOT*" *LAST* TIME WE HAD MANEUVERS--

..I'M *SORRY*...FOR A MINUTE I THOUGHT *I* WAS PHIL SILVERS.. I'LL BE OKAY IF I CAN JUST VISUALIZE *ED NORTON'S VEST* FOR 30 SECONDS..

HE'S *UP* TO SOMETHING.. ..I *KNOW* HE'S UP TO SOMETHING..

ZiPPy

"KHADAFFY DUCK"

BILL GRIFFITH

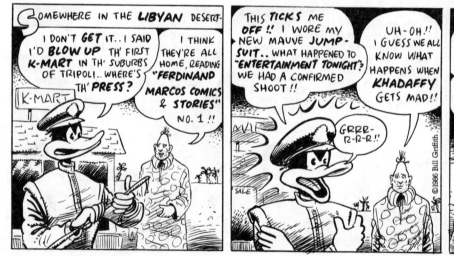

SOMEWHERE IN THE **LIBYAN** DESERT-

I DON'T **GET** IT.. I SAID I'D **BLOW UP** TH' FIRST **K-MART** IN TH' SUBURBS OF TRIPOLI.. WHERE'S TH' **PRESS**?

I THINK THEY'RE ALL HOME, READING "**FERDINAND MARCOS** COMICS & STORIES" NO. 1 !!

K-MART

THIS **TICKS** ME **OFF**!! I WORE MY NEW MAUVE **JUMP-SUIT**.. WHAT HAPPENED TO "**ENTERTAINMENT TONIGHT**"? WE HAD A CONFIRMED SHOOT !!

UH-OH !! I GUESS WE ALL KNOW WHAT HAPPENS WHEN **KHADAFFY** GETS MAD !!

GRRR-R-R-R!!

SALE

©1986 Bill Griffith

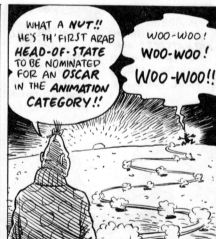

WHAT A **NUT**!! HE'S TH' FIRST ARAB **HEAD-OF-STATE** TO BE NOMINATED FOR AN **OSCAR** IN THE **ANIMATION** CATEGORY !!

WOO-WOO! WOO-WOO! WOO-WOO!!

"HOW MANY SHOES?" BILL GRIFFITH

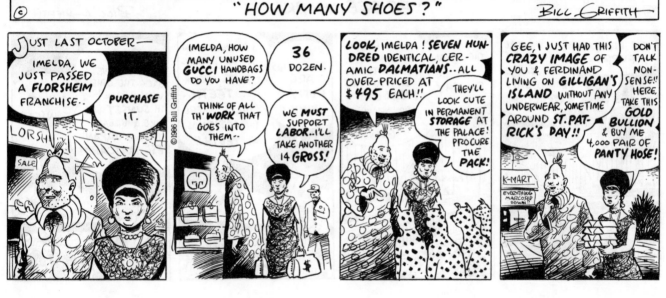

Z i P p y

"BRIDGE WORK"

BILL GRIFFITH

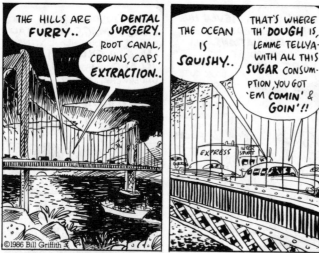

THE HILLS ARE FURRY..

DENTAL SURGERY. ROOT CANAL, CROWNS, CAPS, EXTRACTION..

THE OCEAN IS SQUISHY..

THAT'S WHERE TH' DOUGH IS, LEMME TELLYA- WITH ALL THIS SUGAR CONSUMPTION, YOU GOT 'EM COMIN' & GOIN'!!

©1986 Bill Griffith

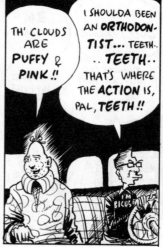

TH' CLOUDS ARE PUFFY & PINK !!

I SHOULDA BEEN AN ORTHODONTIST... TEETH.. ..TEETH.. THAT'S WHERE THE ACTION IS, PAL, TEETH !!

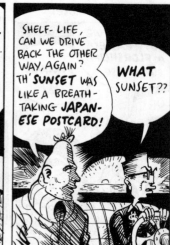

SHELF-LIFE, CAN WE DRIVE BACK THE OTHER WAY, AGAIN? TH' SUNSET WAS LIKE A BREATH-TAKING JAPANESE POSTCARD!

WHAT SUNSET??

"DENTAL CASE"

BILL GRIFFITH

SO WHAT'S ALL THIS FUSS OVER **MOLLY RINGWALD**? YOU WANT **SEXY**? I'LL TAKE **LAINIE KAZAN**!!

GNXLB ZRK.

ANOTHER THING.. WHY SHOULD *I* CARE ABOUT **AFGHANISTAN**? ARE THE RUSSIANS CONCERNED OVER MY **LEAKY ROOF**?

FMRB.

...I'VE GOT THE **ARTERIES** OF A **NINETEEN-YEAR-OLD**.. YOU KNOW WHY? **CLAM JUICE**-- THREE TIMES A DAY--

LNDL.

YOU'RE GONNA NEED A **BRIDGE**, A **CAP**, SIX FILLINGS & A **CROWN**..YOU OUGHTA SEE A DENTIST MORE OFTEN--

DENTIST? I THOUGHT THIS WAS TH' **HOT**, NEW **FLOOR SHOW** AT A **CHIC** DOWNTOWN **NIGHT CLUB**!!

© 1986 Bill Griffith

Z i P p y

"AGAINST THE GRAIN"

BILL GRIFFITH

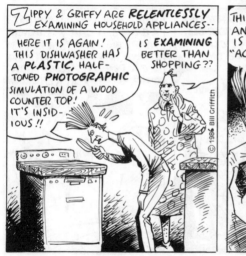

ZIPPY & GRIFFY ARE **RELENTLESSLY** EXAMINING HOUSEHOLD APPLIANCES--

HERE IT IS AGAIN! THIS DISHWASHER HAS A **PLASTIC**, HALF-TONED **PHOTOGRAPHIC** SIMULATION OF A WOOD COUNTER TOP! IT'S INSID-IOUS!!

IS **EXAMINING** BETTER THAN SHOPPING??

© 1986 Bill Griffith

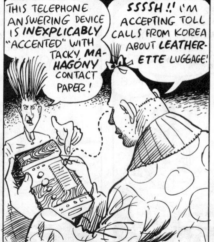

THIS TELEPHONE ANSWERING DEVICE IS **INEXPLICABLY** "ACCENTED" WITH TACKY **MA-HAGONY** CONTACT PAPER!

SSSSH!! I'M ACCEPTING TOLL CALLS FROM KOREA ABOUT **LEATHER-ETTE** LUGGAGE!

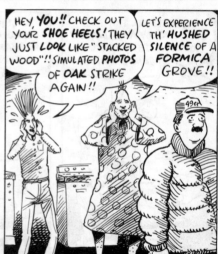

HEY, **YOU!!** CHECK OUT YOUR **SHOE HEELS!** THEY JUST **LOOK** LIKE "STACKED WOOD"!! SIMULATED **PHOTOS** OF **OAK** STRIKE AGAIN!!

LET'S EXPERIENCE TH' **HUSHED SILENCE** OF A **FORMICA GROVE!!**

"MAKING A POINT"

BILL GRIFFITH

Panel 1

Zippy takes a healthy **BITE** out of his favorite **DESSERT** product...

UH-OH!! THERE'S SOMETHING **HARD** INSIDE MY USUALLY **SOFT**, CHOCOLATE-COVERED, BAKED **SNACK DISC** WITH A CREME CENTER!!

CRACK!

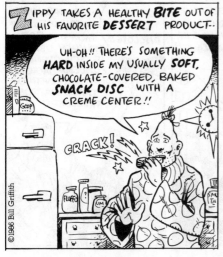

Panel 2

GRIFFY, WHAT DO YOU MAKE OF THIS TINY, OBLONG, **RUSSIAN SPY DEVICE** I FOUND IN MY SOFT **SNACK DISC**?

SPY DEVICE? ZIPPY, THIS IS A **TYLENOL CAPLET**!! HOW DID IT GET INSIDE YOUR **DING-DONG**?

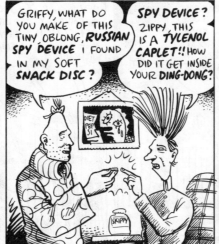

Panel 3

ZIPPY, YOU PUT IT IN THERE **YOURSELF**, DIDN'T YOU?-- **WHY?**

I **CONFESS**-- I WANTED TO DRAW **ATTENTION** TO THE BI-COASTAL THREAT TO **NOUVELLE CUISINE** POSED BY **CASPAR WEINBERGER** AND THE **BÄDER-MEINHOFF** GANG!!

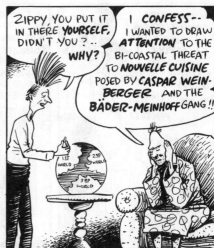

Z i P p y

© "INTER-SPECIES INCIDENT" BILL GRIFFITH

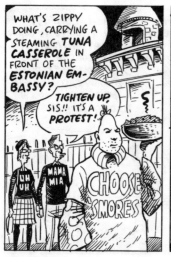

WHAT'S ZIPPY DOING, CARRYING A STEAMING **TUNA CASSEROLE** IN FRONT OF THE **ESTONIAN EMBASSY**?

TIGHTEN UP, SIS!! IT'S A **PROTEST**!

UH UH

MAMA MIA

CHOOSE SMORES

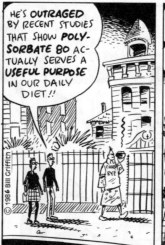

HE'S **OUTRAGED** BY RECENT STUDIES THAT SHOW **POLYSORBATE 80** ACTUALLY SERVES A **USEFUL PURPOSE** IN OUR DAILY DIET!!

© 1986 Bill Griffith

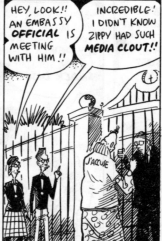

HEY, LOOK!! AN EMBASSY **OFFICIAL** IS MEETING WITH HIM!!

INCREDIBLE! I DIDN'T KNOW ZIPPY HAD SUCH **MEDIA CLOUT!!**

J'ACCUSE

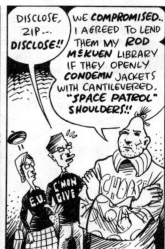

DISCLOSE, ZIP --- **DISCLOSE!!**

WE **COMPROMISED**.. I AGREED TO LEND THEM MY **ROD McKUEN** LIBRARY IF THEY OPENLY **CONDEMN** JACKETS WITH CANTILEVERED, **"SPACE PATROL"** SHOULDERS!!

E.U.

C'MON GIVE

CHOOSE

"BEHIND EVERY GREAT MAN"

BILL GRIFFITH

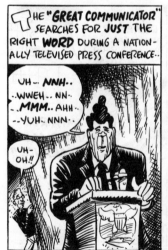

THE "GREAT COMMUNICATOR" SEARCHES FOR JUST THE RIGHT WORD DURING A NATIONALLY TELEVISED PRESS CONFERENCE..

UH.. NNH.. ..WWEH.. NN.. MMM..AHH.. ..YUH.. NNN..

UH-OH!!

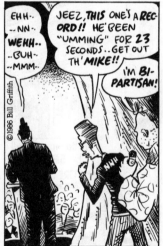

EHH.. ..NN.. WEHH.. ..BUH.. ..MMM..

JEEZ, THIS ONE'S A RECORD!! HE'S BEEN "UMMING" FOR 23 SECONDS..GET OUT TH' MIKE!!

I'M BI-PARTISAN!

©1986 Bill Griffith

OKAY, HIS MINI-PHONE'S READY TO RECEIVE! GO!

..RON, THIS IS 1955..EVERYTHING IS OKAY..G.E. JUST PICKED UP YOUR OPTION FOR ANOTHER SEASON..

EHH.. ..NNH

..UH..YES..WELL, SAM, AS YOU KNOW THINGS HAVE NEVER BEEN BETTER FOR THE UNEMPLOYED YOUTH OF DETROIT..UH.. ..ENHHHH..

HE'S SLIPPING AGAIN, QUICK, REMIND HIM HE ONCE CO-STARRED WITH ANGIE DICKINSON IN "THE KILLERS"!

IT'S 1964, RON.. YOU JUST BOUGHT SANTA BARBARA.. ..HAVE A JELLY BEAN.. HAVE A JELLY BEAN..

GE

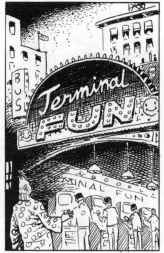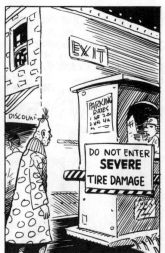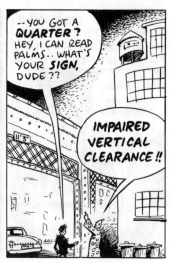

"ACOUSTIC EXPERIENCE"

BILL GRIFFITH

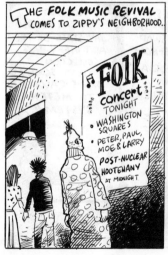

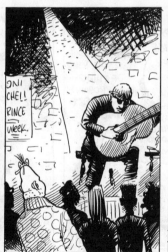

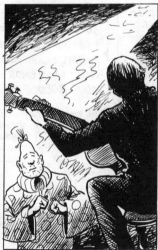

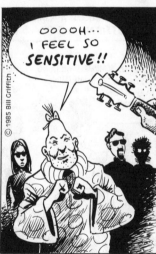

"STATIONERY FRONT"

BILL GRIFFITH

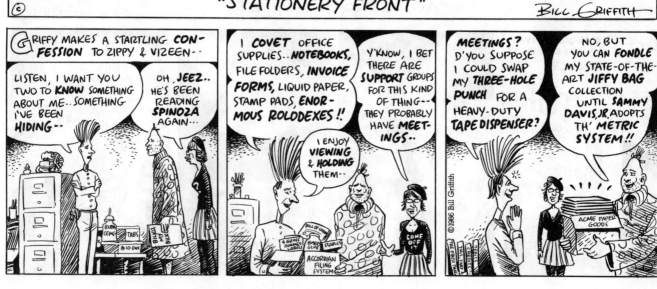

"BURNING NATIONAL ISSUE"

BILL GRIFFITH

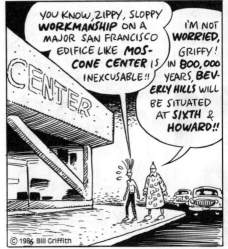

YOU KNOW, ZIPPY, SLOPPY **WORKMANSHIP** ON A MAJOR SAN FRANCISCO EDIFICE LIKE MOS-CONE CENTER IS INEXCUSABLE!!

I'M NOT **WORRIED**, GRIFFY! IN 800,000 YEARS, **BEVERLY HILLS** WILL BE SITUATED AT **SIXTH & HOWARD!!**

© 1986 Bill Griffith

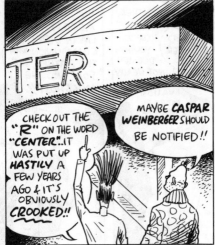

CHECK OUT THE **"R"** ON THE WORD **"CENTER"**..IT WAS PUT UP **HASTILY** A FEW YEARS AGO & IT'S OBVIOUSLY **CROOKED!!**

MAYBE **CASPAR WEINBERGER** SHOULD BE NOTIFIED!!

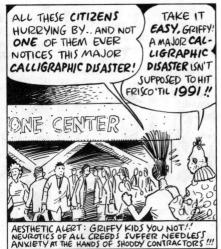

ALL THESE **CITIZENS** HURRYING BY.. AND NOT **ONE** OF THEM EVER NOTICES THIS MAJOR **CALLIGRAPHIC DISASTER!**

TAKE IT **EASY**, GRIFFY! A MAJOR **CALLIGRAPHIC DISASTER** ISN'T SUPPOSED TO HIT FRISCO 'TIL **1991!!**

AESTHETIC ALERT: GRIFFY KIDS YOU NOT!! NEUROTICS OF ALL CREEDS SUFFER NEEDLESS ANXIETY AT THE HANDS OF SHODDY CONTRACTORS !!!

Z i P p y

© "FOND OF MENTALISM" — BILL GRIFFITH

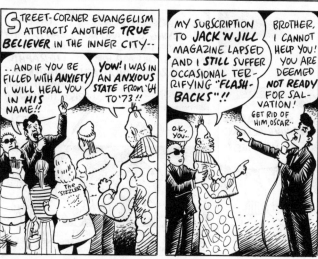

STREET-CORNER EVANGELISM ATTRACTS ANOTHER **TRUE BELIEVER** IN THE INNER CITY--

..AND IF YOU BE FILLED WITH **ANXIETY** I WILL HEAL YOU IN **HIS** NAME!!

YOW! I WAS IN AN **ANXIOUS STATE** FROM '64 TO '73!!

The "SIZZLER"

MY SUBSCRIPTION TO **JACK 'N JILL** MAGAZINE LAPSED AND **I STILL** SUFFER OCCASIONAL TERRIFYING "**FLASH-BACKS**"!!

O.K. YOU...

BROTHER, I CANNOT HELP YOU! YOU ARE DEEMED **NOT READY** FOR SALVATION! GET RID OF HIM, OSCAR!

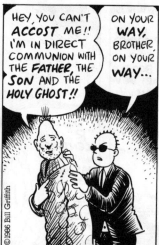

HEY, YOU CAN'T **ACCOST ME!!** I'M IN DIRECT COMMUNION WITH THE **FATHER**, THE **SON** AND THE **HOLY GHOST!!**

ON YOUR **WAY**, BROTHER, ON YOUR **WAY**...

© 1986 Bill Griffith

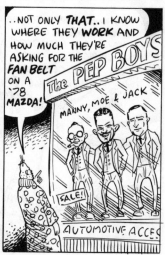

..NOT ONLY **THAT**.. I KNOW WHERE THEY **WORK** AND HOW MUCH THEY'RE ASKING FOR THE **FAN BELT** ON A '78 **MAZDA!**

The PEP BOYS

MANNY, MOE & JACK

SALE!

AUTOMOTIVE ACCES

ZiPPY

"FINGER-LICKIN' PHANTASM"

BILL GRIFFITH

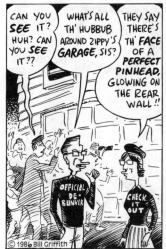

CAN YOU **SEE** IT? HUH? CAN YOU **SEE** IT??

WHAT'S ALL TH' HUBBUB AROUND ZIPPY'S **GARAGE**, SIS?

THEY SAY THERE'S TH' **FACE** OF A **PERFECT PINHEAD**, GLOWING ON THE REAR WALL!!

OFFICIAL DE-BUNKER

CHECK IT OUT

© 1986 Bill Griffith

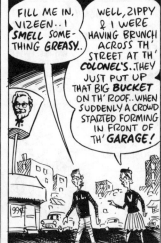

FILL ME IN, VIZEEN.. I **SMELL** SOMETHING **GREASY**..

WELL, ZIPPY & I WERE HAVING BRUNCH ACROSS TH' STREET AT TH' **COLONEL'S**..THEY JUST PUT UP THAT BIG **BUCKET** ON TH' ROOF.. WHEN SUDDENLY A CROWD STARTED FORMING IN FRONT OF TH' **GARAGE**!

BUCKET O'SNOUT

OPEN

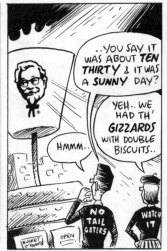

HMMM..

..YOU SAY IT WAS ABOUT **TEN THIRTY** & IT WAS A **SUNNY** DAY?

YEH.. WE HAD TH' **GIZZARDS** WITH DOUBLE BISCUITS..

NO TAIL GATERS

WATCH IT

BUCKET O'SNOUT

OPEN

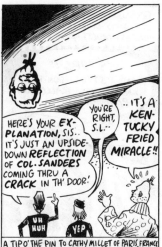

HERE'S YOUR EX-**PLANATION**, SIS.. IT'S JUST AN UPSIDE-DOWN **REFLECTION** OF **COL. SANDERS** COMING THRU A **CRACK** IN TH' DOOR!

YOU'RE RIGHT, S.L..

..IT'S A **KEN-TUCKY FRIED MIRACLE**!!

UH HUH

YEP

A TIP O' THE PIN TO CATHY MILLET OF PARIS, FRANCE

Z i P p y

"DAWN OF A NEW EVENING"

BILL GRIFFITH

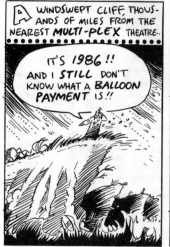

A WINDSWEPT CLIFF, THOUSANDS OF MILES FROM THE NEAREST *MULTI-PLEX* THEATRE...

IT'S *1986*!! AND I *STILL* DON'T KNOW WHAT A *BALLOON PAYMENT* IS!!

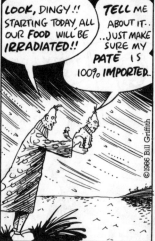

LOOK, DINGY!! STARTING TODAY ALL OUR *FOOD* WILL BE *IRRADIATED*!!

TELL ME ABOUT IT... ...JUST MAKE SURE MY *PATÉ* IS 100% *IMPORTED*.

©1986 Bill Griffith

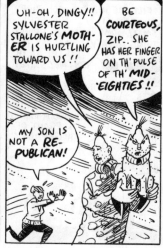

UH-OH, DINGY!! SYLVESTER STALLONE'S *MOTHER* IS HURTLING TOWARD US!!

BE *COURTEOUS*, ZIP... SHE HAS HER FINGER ON TH' PULSE OF TH' *MID-EIGHTIES*!!

MY SON IS NOT A *RE-PUBLICAN*!

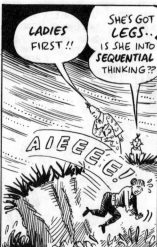

LADIES FIRST!!

SHE'S GOT *LEGS*... IS SHE INTO *SEQUENTIAL THINKING*??

AIEEEE!

"HEADACHE, NEURITIS & NOSTALGIA"

BILL GRIFFITH

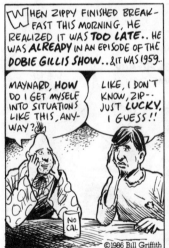

WHEN ZIPPY FINISHED BREAK-FAST THIS MORNING, HE REALIZED IT WAS **TOO LATE**.. HE WAS **ALREADY** IN AN EPISODE OF THE **DOBIE GILLIS SHOW**.. &IT WAS 1959..

MAYNARD, **HOW** DO I GET MYSELF INTO SITUATIONS LIKE THIS, ANY-WAY?

LIKE, I DON'T KNOW, ZIP-- JUST **LUCKY**, I GUESS!!

NO CAL

©1986 Bill Griffith

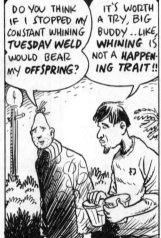

DO YOU THINK IF I STOPPED MY CONSTANT WHINING **TUESDAY WELD** WOULD BEAR MY **OFFSPRING?**

IT'S WORTH A TRY, BIG BUDDY.. LIKE, WHINING IS NOT A **HAPPEN-ING TRAIT!!**

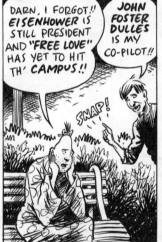

DARN, I FORGOT!! **EISENHOWER** IS STILL PRESIDENT AND **"FREE LOVE"** HAS YET TO HIT TH' **CAMPUS!!**

JOHN FOSTER DULLES IS MY CO-PILOT!!

SNAP!

HEY, I JUST HAD A MAJOR HALLUCINATION.. LIKE, WHY DON'T YOU JUST **DYE** YOUR HAIR **BRIGHT WHITE** & WEAR NEATLY PRES-SED **MADRAS** "SHIRT-JACS"?!

THAT'S A **COOL** IDEA, MAYNARD.. NOW LET'S GO TO **SLEEP** UNTIL SOME-ONE INVENTS **TOFUTTI!!**

"CIAO, ZEE-PEE!!"

BILL GRIFFITH

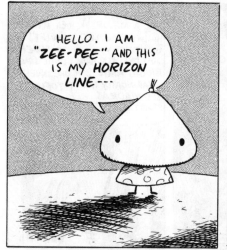

HELLO. I AM "ZEE-PEE" AND THIS IS MY *HORIZON LINE*---

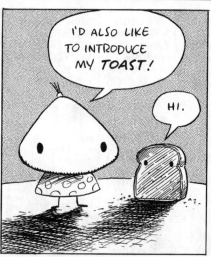

I'D ALSO LIKE TO INTRODUCE MY *TOAST*!

HI.

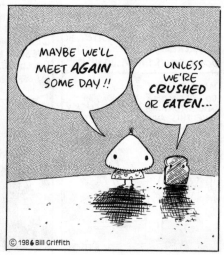

MAYBE WE'LL MEET *AGAIN* SOME DAY!!

UNLESS WE'RE *CRUSHED* OR *EATEN*...

© 1986 Bill Griffith

"ZEE-PEE'S BIG ADVENTURE"

BILL GRIFFITH

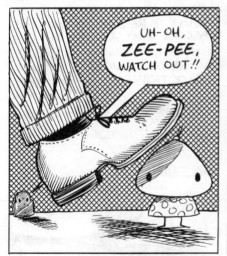

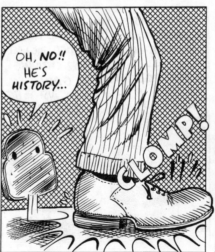

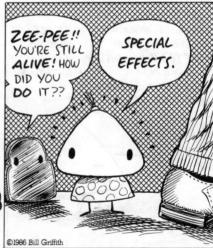

ZiPpy

"LET'S TAKE LUNCH"

Bill Griffith

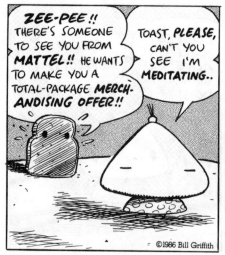

ZEE-PEE!! THERE'S SOMEONE TO SEE YOU FROM MATTEL!! HE WANTS TO MAKE YOU A TOTAL-PACKAGE MERCHANDISING OFFER!!

TOAST, PLEASE, CAN'T YOU SEE I'M MEDITATING..

©1986 Bill Griffith

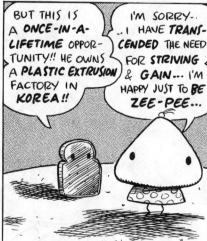

BUT THIS IS A ONCE-IN-A-LIFETIME OPPORTUNITY!! HE OWNS A PLASTIC EXTRUSION FACTORY IN KOREA!!

I'M SORRY... I HAVE TRANSCENDED THE NEED FOR STRIVING & GAIN... I'M HAPPY JUST TO BE ZEE-PEE...

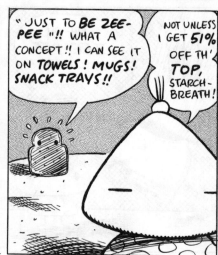

"JUST TO BE ZEE-PEE"!! WHAT A CONCEPT!! I CAN SEE IT ON TOWELS! MUGS! SNACK TRAYS!!

NOT UNLESS I GET 51% OFF TH' TOP, STARCH-BREATH!

"ANTHROPOLOGY A'LA MARINARA"

BILL GRIFFITH

Panel 1:

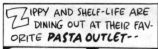

ZIPPY AND SHELF-LIFE ARE DINING OUT AT THEIR FAVORITE **PASTA OUTLET**--

S.L., **WHY** DOES THAT MAN HAVE **FOURTEEN HAIRS** DANGLING FROM TH' BACK OF HIS **SHORT** COIFFURE?

I DON'T KNOW, ZIP.. BUT I'M BEGINNING TO LOSE MY APPETITE FOR **CANELLONI!!**

Panel 2:

I THINK MAYBE IT'S A **TRANSITIONAL** STAGE FROM THE OLD **HIPPIE HAIRDO** TO THE "PROFESSIONAL" LOOK.. PERSONALLY, I'M **SICKENED** BY THE PHENOMENON..

WHAT'S A "HIPPIE," SHELF-LIFE??

KEEP YOUR DISTANCE

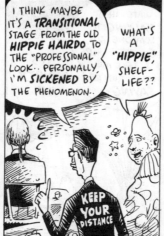

Panel 3:

A HIPPIE IS SOMEONE FROM **AUSTRALIA** OR **BAKERSFIELD** WHO TOOK TOO MUCH **MEDICINE** AND NOW HAS TO FOLLOW THE **GRATEFUL DEAD** FROM PHOENIX TO **JERSEY CITY** UNTIL 1999!!

..JUST LIKE **NANCY SINATRA!!**

©1986 Bill Griffith

Panel 4:

EXCUSE ME, SIR, WILL YOU BE HAVING TH' **ORANGE CREME BRULEE** FOR DESSERT?

BRING ME TH' GREATEST **HITS** OF TH' **"STRAWBERRY ALARM CLOCK"** I'M HAVING MY **NINETEENTH NERVOUS COMEBACK!!**

"NO JOKE"

BILL GRIFFITH

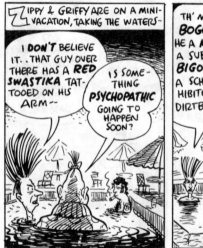

ZIPPY & GRIFFY ARE ON A MINI-VACATION, TAKING THE WATERS..

I DON'T BELIEVE IT.. THAT GUY OVER THERE HAS A **RED SWASTIKA** TATTOOED ON HIS ARM--

IS SOMETHING **PSYCHOPATHIC** GOING TO HAPPEN SOON?

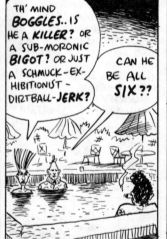

TH' MIND **BOGGLES**.. IS HE A **KILLER**? OR A SUB-MORONIC **BIGOT**? OR JUST A SCHMUCK-EXHIBITIONIST-DIRTBALL-**JERK**?

CAN HE BE ALL **SIX**??

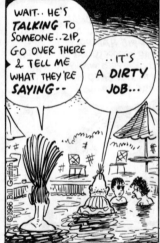

WAIT.. HE'S **TALKING** TO SOMEONE.. ZIP, GO OVER THERE & TELL ME WHAT THEY'RE **SAYING**--

..IT'S A **DIRTY JOB**...

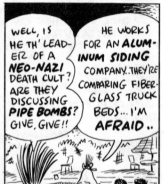

WELL, IS HE TH' LEADER OF A **NEO-NAZI** DEATH CULT? ARE THEY DISCUSSING **PIPE BOMBS**? GIVE, GIVE!!

HE WORKS FOR AN **ALUMINUM SIDING** COMPANY..THEY'RE COMPARING FIBERGLASS TRUCK BEDS.. I'M **AFRAID**..

"NOT A COMIC STRIP"

BILL GRIFFITH

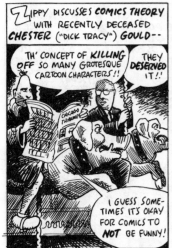

ZIPPY DISCUSSES **COMICS THEORY** WITH RECENTLY DECEASED **CHESTER** ("DICK TRACY") **GOULD**--

TH' CONCEPT OF **KILLING OFF** SO MANY GROTESQUE CARTOON CHARACTERS !!

THEY **DESERVED** IT !!

I GUESS SOME-TIMES ITS OKAY FOR COMICS TO **NOT** BE FUNNY!

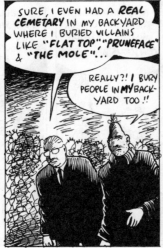

SURE, I EVEN HAD A **REAL** **CEMETARY** IN MY BACKYARD WHERE I BURIED VILLAINS LIKE "**FLAT TOP**","**PRUNEFACE**" & "**THE MOLE**"...

REALLY?! **I** BURY PEOPLE IN **MY** BACK-YARD TOO !!

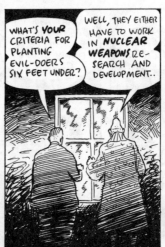

WHAT'S **YOUR** CRITERIA FOR PLANTING EVIL-DOERS SIX FEET UNDER?

WELL, THEY EITHER HAVE TO WORK IN **NUCLEAR WEAPONS** RE-SEARCH AND DEVELOPMENT..

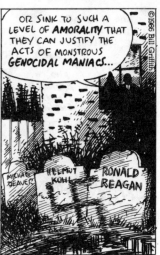

OR SINK TO SUCH A LEVEL OF **AMORALITY** THAT THEY CAN JUSTIFY THE ACTS OF MONSTROUS **GENOCIDAL MANIACS**...

MICHAEL DEAVER

HELMUT KOHL

RONALD REAGAN

"TRICK OR RETREAT" BILL GRIFFITH

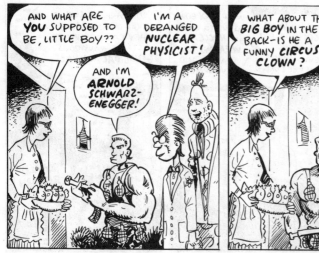

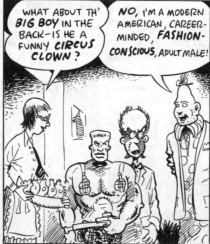

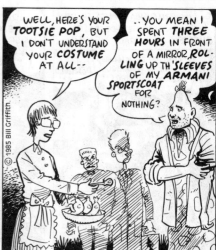

ZIPPY

"THE TRUE MEANING OF CHRISTMAS"

BILL GRIFFITH

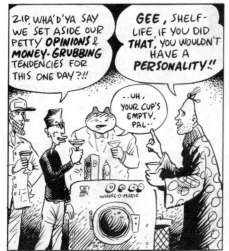

ZIP, WHA'D'YA SAY WE SET ASIDE OUR PETTY **OPINIONS** & **MONEY-GRUBBING** TENDENCIES FOR THIS ONE DAY?!!

GEE, SHELF-LIFE, IF YOU DID **THAT**, YOU WOULDN'T HAVE A **PERSONALITY!!**

..UH, YOUR CUP'S EMPTY, PAL..

WHIRL-O-MATIC

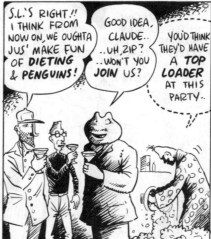

S.L.'S RIGHT!! I THINK FROM NOW ON, WE OUGHTA JUS' MAKE FUN OF **DIETING** & **PENGUINS!**

GOOD IDEA, CLAUDE.. ..UH, ZIP? ..WON'T YOU **JOIN US?**

YOU'D THINK THEY'D HAVE A **TOP LOADER** AT THIS PARTY.

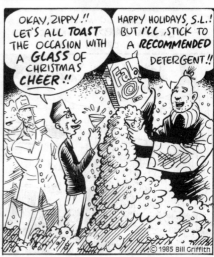

OKAY, ZIPPY!! LET'S ALL **TOAST** THE OCCASION WITH A **GLASS** OF CHRISTMAS **CHEER!!**

HAPPY HOLIDAYS, S.L.! BUT **I'LL** STICK TO A **RECOMMENDED** DETERGENT!!

"THE REAL DIRT"

BILL GRIFFITH

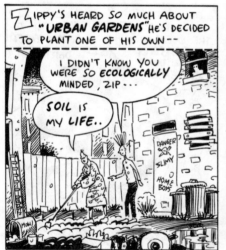

ZIPPY'S HEARD SO MUCH ABOUT "URBAN GARDENS" HE'S DECIDED TO PLANT ONE OF HIS OWN--

I DIDN'T KNOW YOU WERE SO ECOLOGICALLY MINDED, ZIP...

SOIL IS MY LIFE..

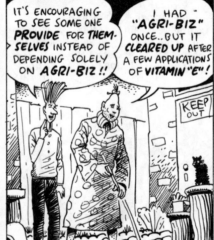

IT'S ENCOURAGING TO SEE SOME ONE PROVIDE FOR THEMSELVES INSTEAD OF DEPENDING SOLELY ON AGRI-BIZ!!

I HAD "AGRI-BIZ" ONCE.. BUT IT CLEARED UP AFTER A FEW APPLICATIONS OF VITAMIN "E"!

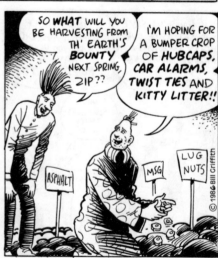

SO WHAT WILL YOU BE HARVESTING FROM TH' EARTH'S BOUNTY NEXT SPRING, ZIP??

I'M HOPING FOR A BUMPER CROP OF HUBCAPS, CAR ALARMS, TWIST TIES AND KITTY LITTER!!

© 1986 Bill Griffith

"CLEAR THINKING"

BILL GRIFFITH

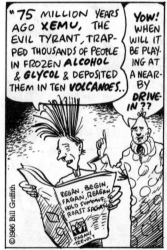

"75 MILLION YEARS AGO **XEMU**, THE EVIL TYRANT, TRAPPED THOUSANDS OF PEOPLE IN FROZEN **ALCOHOL** & **GLYCOL** & DEPOSITED THEM IN TEN **VOLCANOES**..

YOW! WHEN WILL IT BE PLAYING AT A NEARBY **DRIVE-IN**??

© 1986 Bill Griffith

REGAN, BEGIN, FAGAN, REAGAN HOLD SUMMIT ROAST SAGA?

PAGAN REVOLT

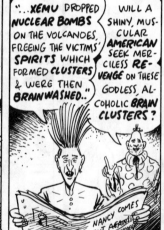

"...**XEMU** DROPPED **NUCLEAR BOMBS** ON THE VOLCANOES, FREEING THE VICTIMS' **SPIRITS** WHICH FORMED **CLUSTERS** & WERE THEN **BRAINWASHED**..

WILL A SHINY, MUSCULAR **AMERICAN** SEEK MERCILESS **REVENGE** ON THESE GODLESS, ALCOHOLIC **BRAIN CLUSTERS**?

NANCY COMES OUT AGAINST DRUGS, MURDER

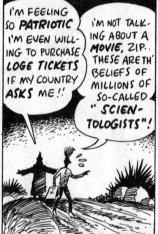

I'M FEELING SO **PATRIOTIC** I'M EVEN WILLING TO PURCHASE **LOGE TICKETS** IF MY COUNTRY **ASKS** ME !!

I'M NOT TALKING ABOUT A **MOVIE**, ZIP.. THESE ARE TH' BELIEFS OF MILLIONS OF SO-CALLED "**SCIENTOLOGISTS**"!

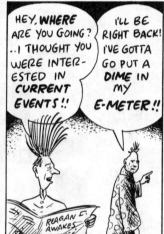

HEY, **WHERE** ARE YOU GOING? ..I THOUGHT YOU WERE INTERESTED IN **CURRENT EVENTS** !!

I'LL BE RIGHT BACK! I'VE GOTTA GO PUT A **DIME** IN MY **E-METER** !!

REAGAN E. AWAKES, TWITCHES

"MYSTERIES OF ADVERTISING"

BILL GRIFFITH

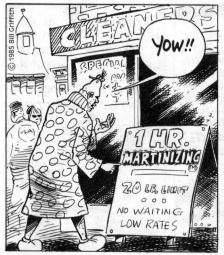

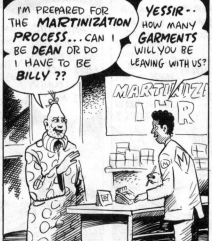

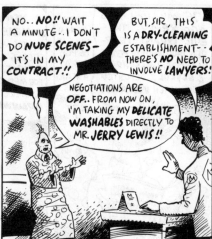

Z i P p y

"STATUE OF LIMITATIONS"

BILL GRIFFITH

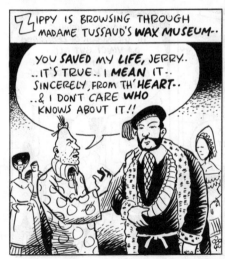

Zippy is browsing through Madame Tussaud's **WAX MUSEUM**..

You **SAVED** MY **LIFE**, JERRY.. ..IT'S TRUE.. I **MEAN** IT.. SINCERELY, FROM TH' **HEART**.. ..& I DON'T CARE **WHO** KNOWS ABOUT IT !!

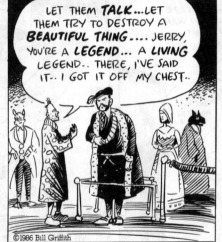

LET THEM **TALK**...LET THEM TRY TO DESTROY A **BEAUTIFUL THING**.....JERRY, YOU'RE A **LEGEND**... A **LIVING** LEGEND.. THERE, I'VE SAID IT.. I GOT IT OFF MY CHEST..

©1986 Bill Griffith

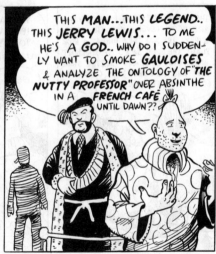

THIS **MAN**...THIS **LEGEND**.. THIS **JERRY LEWIS**... TO ME HE'S A **GOD**.. WHY DO I SUDDENLY WANT TO SMOKE **GAULOISES** & ANALYZE THE ONTOLOGY OF **"THE NUTTY PROFESSOR"** OVER ABSINTHE IN A **FRENCH CAFÉ** UNTIL DAWN??

© "GRID-LOCK" BILL GRIFFITH

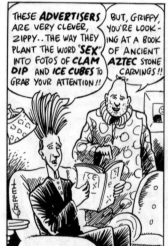

THESE **ADVERTISERS** ARE VERY **CLEVER**, ZIPPY.. THE WAY THEY PLANT THE WORD "**SEX**" INTO FOTOS OF **CLAM DIP** AND **ICE CUBES** TO GRAB YOUR ATTENTION!!

BUT, GRIFFY, YOU'RE LOOKING AT A BOOK OF ANCIENT **AZTEC** STONE CARVINGS!!

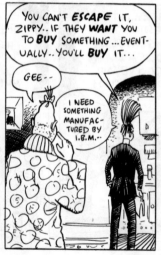

YOU CAN'T **ESCAPE** IT, ZIPPY.. IF THEY **WANT** YOU TO **BUY** SOMETHING ...EVENTUALLY.. YOU'LL **BUY** IT...

GEE--

I NEED SOMETHING MANUFACTURED BY I.B.M.--

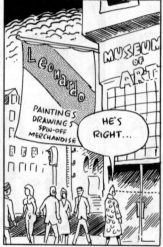

Leonardo

MUSEUM OF ART

PAINTINGS
DRAWINGS
SPIN-OFF
MERCHANDISE

HE'S RIGHT...

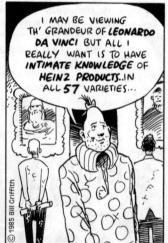

I MAY BE VIEWING TH' GRANDEUR OF **LEONARDO DA VINCI** BUT ALL I REALLY WANT IS TO HAVE **INTIMATE KNOWLEDGE** OF **HEINZ PRODUCTS**..IN ALL **57** VARIETIES...

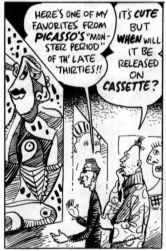
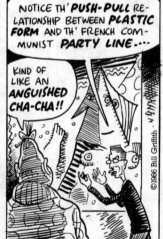
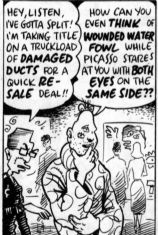
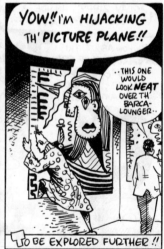

"ART MOVEMENT"

BILL GRIFFITH

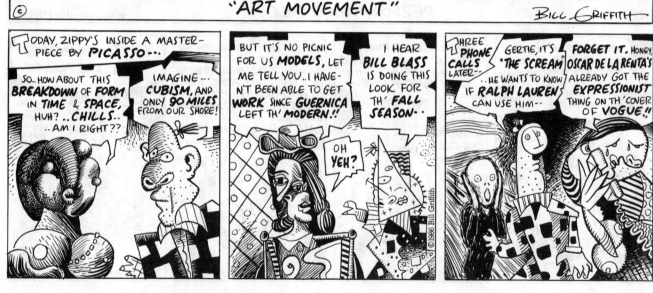

"FRAMED and HUNG" BILL GRIFFITH

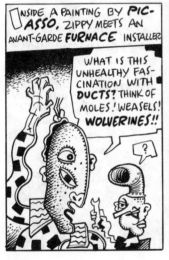

INSIDE A PAINTING BY *PIC-ASSO*, ZIPPY MEETS AN AVANT-GARDE *FURNACE* INSTALLER

WHAT IS THIS UNHEALTHY FAS-CINATION WITH *DUCTS?* THINK OF MOLES! WEASELS! *WOLVERINES!!*

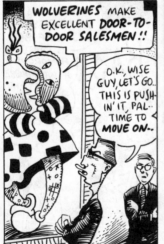

WOLVERINES MAKE EXCELLENT *DOOR-TO-DOOR* SALESMEN!!

O.K., WISE GUY, LET'S GO... THIS IS PUSH-IN' IT, PAL.. TIME TO *MOVE ON*..

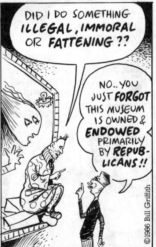

DID I DO SOMETHING *ILLEGAL, IMMORAL* OR *FATTENING* ??

NO.. YOU JUST *FORGOT* THIS MUSEUM IS OWNED & *ENDOWED* PRIMARILY BY *REPUB-LICANS!!*

©1986 Bill Griffith

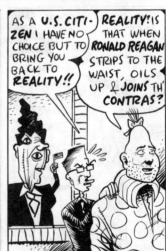

AS A *U.S. CITI-ZEN* I HAVE NO CHOICE BUT TO BRING YOU BACK TO *REALITY!!*

REALITY! IS THAT WHEN *RONALD REAGAN* STRIPS TO THE WAIST, OILS UP & *JOINS* TH' *CONTRAS* ?

"SPRAY WHAT?"

BILL GRIFFITH

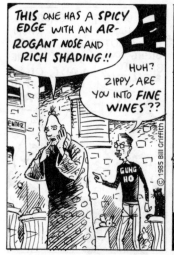

THIS ONE HAS A SPICY EDGE WITH AN ARROGANT NOSE AND RICH SHADING!!

HUH? ZIPPY, ARE YOU INTO FINE WINES??

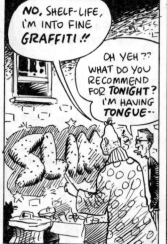

NO, SHELF-LIFE, I'M INTO FINE GRAFFITI!!

OH YEH?? WHAT DO YOU RECOMMEND FOR TONIGHT? I'M HAVING TONGUE--

"KAOS" HAS A COOL AUTHORITY.. AND "SMURF '85" IS QUITE HUMOROUS-- OF COURSE "HUBBA BASIC" AND "LONELY BOY" BOTH HAVE CRISP FINISHES!

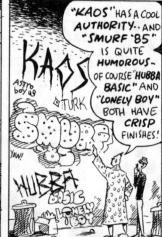

MY FAVORITE WAS "HAPPY HOMES GRANDE," BUT YOU REALLY HAD TO LET IT BREATHE--

GOOD VINTAGE..

LISTEN, I'LL TAKE THIS CAN OF "HOT CHERRY METALLIC"..IT SAYS IT GOES WITH EVERYTHING!!

"FORM FOLLOWS FUN"

BILL GRIFFITH

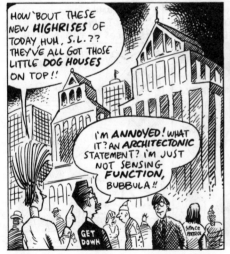

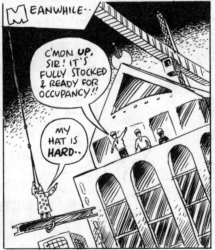

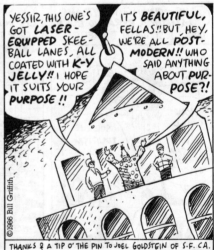

Z i P p y

"POINTILLISM" BILL GRIFFITH

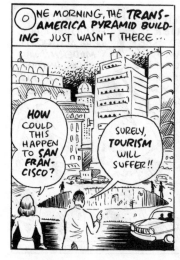

ONE MORNING, THE **TRANS-AMERICA PYRAMID BUILDING** JUST WASN'T THERE...

HOW COULD THIS HAPPEN TO **SAN FRANCISCO**?

SURELY, **TOURISM** WILL SUFFER!!

A BLUE RIBBON COMMITTEE INVESTIGATED THE MATTER & CAME TO AN INESCAPABLE CONCLUSION:

IT'S GONE.

TOTALLY.

A **TORPOR** FELL OVER THE CITY-- A VERITABLE **ENNUI** SETTLED IN---

YOU WANNA HOP ON A **CABLE CAR** OR MAYBE WALK BRISKLY ALONG TH' **WHARF** & STARE AT BOILED **CRABS**?

NAH.. TH' **THRILL** JUST ISN'T **THERE** ANYMORE..

MEANWHILE, AT A MINERAL **HOT SPRINGS** RESORT, 75 MILES TO THE NORTH...

© 1986 Bill Griffith

TELL ME AGAIN HOW IT'S **OKAY** TO BE **TAPERED**..

I NEVER MET A **MONOLITH** I DIDN'T LIKE!!

NO DIVING

....TO BE CONTINUED !!

Z i P P y

"HIGH-RISE LOW POINT"

BILL GRIFFITH

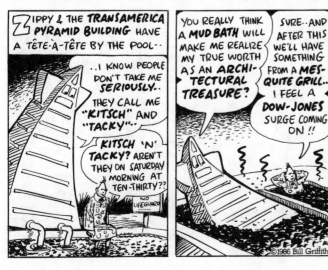

ZIPPY & THE **TRANSAMERICA PYRAMID BUILDING** HAVE A TÊTE-À-TÊTE BY THE POOL..

..I KNOW PEOPLE DON'T TAKE ME **SERIOUSLY**.. THEY CALL ME "**KITSCH**" AND "**TACKY**"..

KITSCH 'N' TACKY? AREN'T THEY ON SATURDAY MORNING AT TEN-THIRTY??

NO LIFEGUARD

YOU REALLY THINK A **MUD BATH** WILL MAKE ME REALIZE MY TRUE WORTH AS AN **ARCHITECTURAL TREASURE**?

SURE..AND AFTER THIS WE'LL HAVE SOMETHING FROM A **MESQUITE GRILL**.. I FEEL A **DOW-JONES** SURGE COMING ON !!

©1986 Bill Griffith

Y'KNOW, I'M BEGINNING TO UNDERSTAND.. IT'S OKAY TO BE **ODD**.. SO WHAT IF I'M A **WEIRDO**?

I'M GOING INTO **PROFITS!**

TO BE **WEIRD** IS TO BE **ALIVE!!**

I'M READY TO GO BACK TO THE **CITY** NOW!! FILL ME WITH **COMMUTERS & ACTUARIAL TABLES!**

OKAY.. LET'S LISTEN TO **LITE ROCK** AND THINK ABOUT **CLIMBING INSURANCE RATES!!**

"BIG BUILD-UP"

BILL GRIFFITH

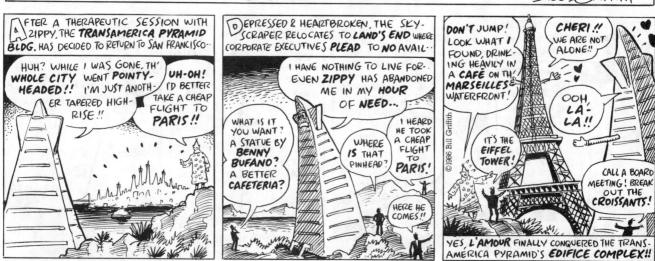

"WEIRD SURVEY"

BILL GRIFFITH

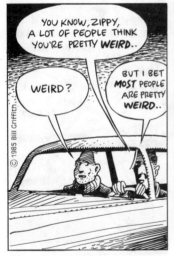

YOU KNOW, ZIPPY, A LOT OF PEOPLE THINK YOU'RE PRETTY **WEIRD**..

WEIRD?

BUT I BET **MOST** PEOPLE ARE PRETTY **WEIRD**..

© 1985 Bill Griffith

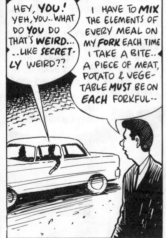

HEY, **YOU**! YEH, YOU..WHAT DO **YOU** DO THAT'S **WEIRD**... ..LIKE **SECRETLY** WEIRD??

I HAVE TO **MIX** THE ELEMENTS OF EVERY MEAL ON MY **FORK** EACH TIME I TAKE A BITE.. A PIECE OF MEAT, POTATO & VEGETABLE **MUST** BE ON **EACH** FORKFUL--

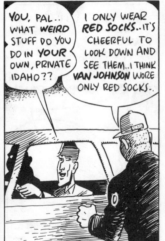

YOU, PAL.. WHAT **WEIRD** STUFF DO YOU DO IN **YOUR** OWN, PRIVATE IDAHO??

I ONLY WEAR **RED SOCKS**..IT'S CHEERFUL TO LOOK DOWN AND SEE THEM..I THINK **VAN JOHNSON** WORE ONLY RED SOCKS..

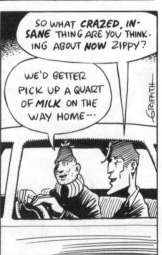

SO WHAT **CRAZED, INSANE** THING ARE YOU THINKING ABOUT **NOW** ZIPPY?

WE'D BETTER PICK UP A QUART OF **MILK** ON THE WAY HOME---

GRIFFITH

ZiPPy

"A FLUKE THING"

BILL GRIFFITH

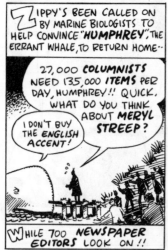

ZIPPY'S BEEN CALLED ON BY MARINE BIOLOGISTS TO HELP CONVINCE "HUMPHREY", THE ERRANT WHALE, TO RETURN HOME...

27,000 COLUMNISTS NEED 135,000 ITEMS PER DAY, HUMPHREY!! QUICK, WHAT DO YOU THINK ABOUT MERYL STREEP?

I DON'T BUY THE ENGLISH ACCENT!

WHILE 700 NEWSPAPER EDITORS LOOK ON!!

HAVE YOU SEEN PINOCCHIO? DO YOU OWN A VCR?

LISTEN, HOW'S GREGORY PECK? I HAVEN'T SEEN ANYTHING BY HIM IN YEARS... ALL THIS "RAMBO" GARBAGE...

MILLIONS OF PEOPLE ARE DEPENDING ON YOU FOR A HAPPY ENDING -- I HOPE YOU HAVEN'T SIGNED WITH A MAJOR STUDIO YET...

WHAT'S ALL TH' FUSS? I JUST WANTED TO BE NEAR RENO!! NEXT TO BANGING ON STEEL PIPES, WHAT I LIKE BEST IS A NICE BALLAD BY WAYNE NEWTON!

ZIPPY!! WHAT DID HE SAY? WE'RE ALL ON DEADLINE!!

HUMPHREY, DID WE JUST MAKE ANOTHER ILLEGAL LEFT TURN?

TALK TO MY AGENT...

©1985 Bill Griffith

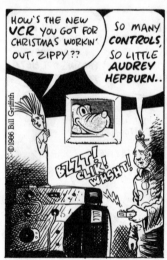

"GONE WITH THE REWIND"

Bill Griffith

Panel 1:
HOW'S THE NEW **VCR** YOU GOT FOR CHRISTMAS WORKIN' OUT, ZIPPY??

SO MANY **CONTROLS**, SO LITTLE **AUDREY HEPBURN**..

BZZT! CLIK! WNGHT!!

Panel 2:
IT WAS **BOUND** TO HAPPEN-- ZIPPY HIT THE **WRONG** BUTTON ON HIS REMOTE CONTROL & TRAVELLED **BACK** IN TIME TO 1886!

YOU MEAN THIS ISN'T AN **ABC** SPECIAL ABOUT **RAW, HUMAN TURMOIL** AGAINST A BACKDROP OF **CRAZED ANIMAL PASSIONS**?

AIN'T **BARNUM** GONNA **MISS** YOU, BUNKY!

BZZZHT!

Panel 3:

PARDON ME, BUT **WHERE** CAN I OBTAIN **INSTANTANEOUS** ELECTRONIC **INTER-COMMUNICATION** & BE SURE OF RANDOM ACCESS TO AN I.B.M. **MAIN-FRAME**?

DREADFUL SORRY, SIR! WE'RE NOT EVEN **CABLE READY**!!

MINSTREL GARDE

Panel 4:

WOW.. I ALSO HAVE A SNEAKING SUSPICION THAT **MICROWAVE COOKERY** IS VIRTUALLY **UNHEARD-OF** IN THIS WACKY, NUTTY, UN-INHIBITED CENTURY!!

RAW HUMAN TURMOIL, MR.! ONLY **5¢**!!

FWIT!

ZiPPy

"PROGRAMMABLE EVENT"

BILL GRIFFITH

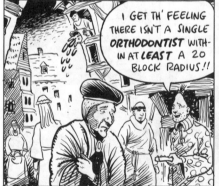

LOST IN 1886, ZIPPY PUSHES **BOTH** "MUTE" AND "REWIND" ON HIS **RE-MOTE CONTROL** & WINDS UP IN **13TH CENTURY PARIS** ON GROUND HOG DAY.

I GET TH' FEELING THERE ISN'T A SINGLE **ORTHODONTIST** WITHIN AT **LEAST** A 20 BLOCK RADIUS!!

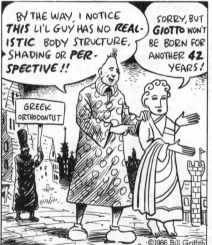

BY THE WAY, I NOTICE **THIS** LI'L GUY HAS NO **REALISTIC** BODY STRUCTURE, SHADING OR **PERSPECTIVE**!!

SORRY, BUT **GIOTTO** WON'T BE BORN FOR ANOTHER **42** YEARS!

GREEK ORTHODONTIST

©1986 Bill Griffith

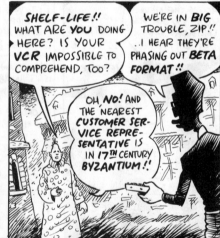

SHELF-LIFE!! WHAT ARE **YOU** DOING HERE? IS YOUR **VCR** IMPOSSIBLE TO COMPREHEND, TOO?

WE'RE IN **BIG** TROUBLE, ZIP!! ..I HEAR THEY'RE PHASING OUT **BETA** FORMAT!!

OH, **NO!** AND THE **NEAREST CUSTOMER SERVICE REPRESENTATIVE** IS IN **17TH** CENTURY **BYZANTIUM!!**

"HYSTERICAL DOCUMENT"

BILL GRIFFITH

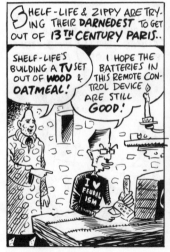

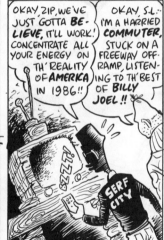

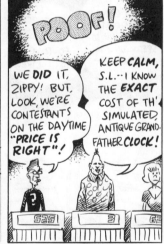

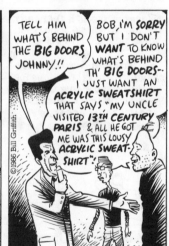

"SHRINK TO FIT"

BILL GRIFFITH

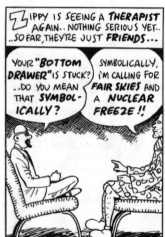

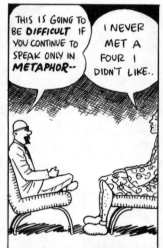

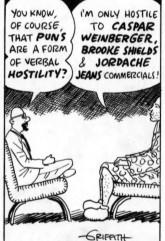

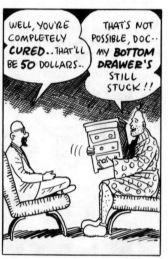

"MIND-WRESTLING FROM ATLANTA"

BILL GRIFFITH

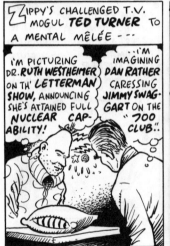

ZIPPY'S CHALLENGED T.V. MOGUL **TED TURNER** TO A MENTAL MÊLÉE ---

I'M PICTURING DR. **RUTH WESTHEIMER** ON TH' **LETTERMAN** SHOW, ANNOUNCING SHE'S ATTAINED FULL **NUCLEAR CAPABILITY!**

..I'M IMAGINING **DAN RATHER** CARESSING **JIMMY SWAGGART** ON THE "**700 CLUB**"..

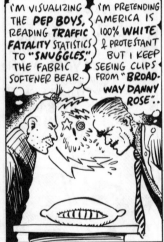

I'M VISUALIZING THE **PEP BOYS**, READING **TRAFFIC FATALITY** STATISTICS TO "**SNUGGLES**," THE FABRIC SOFTENER BEAR..

I'M PRETENDING AMERICA IS 100% **WHITE** & PROTESTANT BUT I KEEP SEEING CLIPS FROM "**BROADWAY DANNY ROSE**"..

© 1985 Bill Griffith

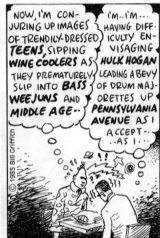

NOW, I'M CONJURING UP IMAGES OF TRENDILY-DRESSED **TEENS**, SIPPING **WINE COOLERS** AS THEY PREMATURELY SLIP INTO **BASS WEEJUNS** AND **MIDDLE AGE**..

I'M..I'M... HAVING DIFFICULTY ENVISAGING **HULK HOGAN** LEADING A BEVY OF DRUM MAJORETTES UP **PENNSYLVANIA AVENUE** AS I ACCEPT..AS I...

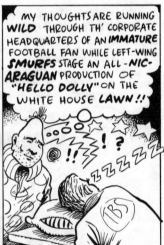

MY THOUGHTS ARE RUNNING **WILD** THROUGH TH' CORPORATE HEADQUARTERS OF AN **IMMATURE** FOOTBALL FAN WHILE LEFT-WING **SMURFS** STAGE AN ALL-**NICARAGUAN** PRODUCTION OF "**HELLO DOLLY**" ON THE WHITE HOUSE **LAWN!!**

Z i P p y

"TITLE SEARCH"

BILL GRIFFITH

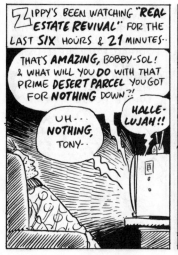

ZIPPY'S BEEN WATCHING "REAL ESTATE REVIVAL" FOR THE LAST SIX HOURS & 21 MINUTES...

THAT'S AMAZING, BOBBY-SOL! & WHAT WILL YOU DO WITH THAT PRIME DESERT PARCEL YOU GOT FOR NOTHING DOWN?!

UH... NOTHING, TONY...

HALLE-LUJAH!!

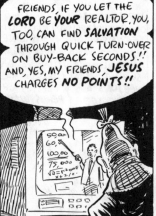

FRIENDS, IF YOU LET THE LORD BE YOUR REALTOR, YOU, TOO, CAN FIND SALVATION THROUGH QUICK TURN-OVER ON BUY-BACK SECONDS!! AND, YES, MY FRIENDS, JESUS CHARGES NO POINTS!!

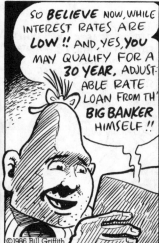

SO BELIEVE NOW, WHILE INTEREST RATES ARE LOW!! AND, YES, YOU MAY QUALIFY FOR A 30 YEAR, ADJUSTABLE RATE LOAN FROM TH' BIG BANKER HIMSELF!!

©1986 Bill Griffith

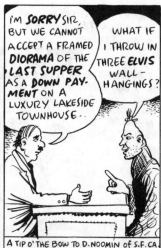

I'M SORRY SIR, BUT WE CANNOT ACCEPT A FRAMED DIORAMA OF THE LAST SUPPER AS A DOWN PAYMENT ON A LUXURY LAKESIDE TOWNHOUSE...

WHAT IF I THROW IN THREE ELVIS WALL-HANGINGS?

A TIP O' THE BOW TO D. NOOMIN OF S.F. CA.

Z i P P y

"LATE NIGHT NERVOUS"

BILL GRIFFITH

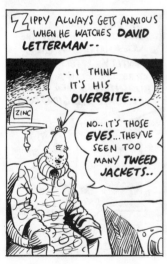

Zippy always gets anxious when he watches **DAVID LETTERMAN**--

..I THINK IT'S HIS **OVERBITE**...

NO.. IT'S THOSE **EYES**...THEY'VE SEEN TOO MANY **TWEED JACKETS**..

ZINC

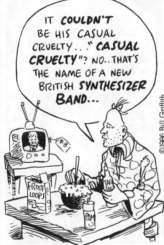

IT **COULDN'T** BE HIS CASUAL CRUELTY... "**CASUAL CRUELTY**"? NO.. THAT'S THE NAME OF A NEW BRITISH **SYNTHESIZER** BAND...

FROOT LOOPS

©1986 Bill Griffith

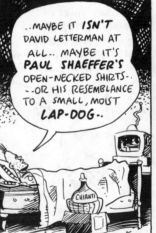

..MAYBE IT **ISN'T** DAVID LETTERMAN AT ALL.. MAYBE IT'S **PAUL SHAEFFER'S** OPEN-NECKED SHIRTS.. --OR HIS RESEMBLANCE TO A SMALL, MOIST **LAP-DOG**..

CHIANTI

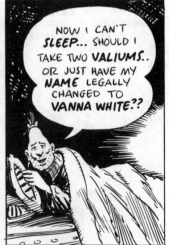

NOW I CAN'T **SLEEP**... SHOULD I TAKE TWO **VALIUMS**.. OR JUST HAVE MY **NAME** LEGALLY CHANGED TO **VANNA WHITE**??

"CLOSE SHAVE"

BILL GRIFFITH

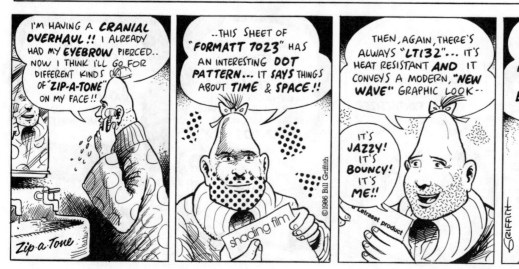

"NO SUCH ADDRESS"

BILL GRIFFITH

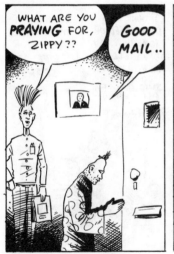

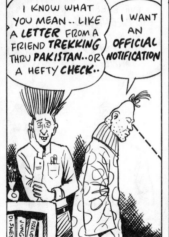

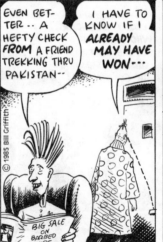

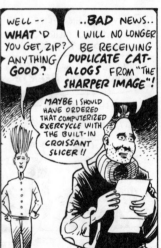

"BAR SHOPPING"

BILL GRIFFITH

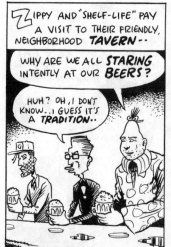

Zippy and "Shelf-Life" pay a visit to their friendly, neighborhood **TAVERN**--

WHY ARE WE ALL **STARING** INTENTLY AT OUR **BEERS**?

HUH? OH, I DON'T KNOW..I GUESS IT'S A **TRADITION**..

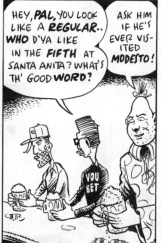

HEY, **PAL**, YOU LOOK LIKE A **REGULAR**.. **WHO** D'YA LIKE IN THE **FIFTH** AT SANTA ANITA? WHAT'S TH' GOOD **WORD**?

ASK HIM IF HE'S EVER VISITED **MODESTO**!

YOU BET

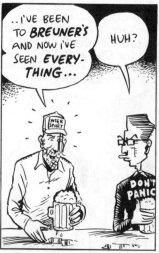

..I'VE BEEN TO **BREUNER'S** AND NOW I'VE SEEN **EVERY-THING**...

HUH?

INTER SPURT

DON'T PANIC

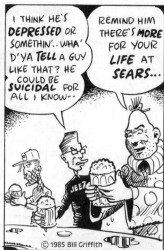

I THINK HE'S **DEPRESSED** OR SOMETHIN'..WHA' D'YA **TELL** A GUY LIKE THAT? HE COULD BE **SUICIDAL** FOR ALL I KNOW--

REMIND HIM THERE'S **MORE** FOR YOUR **LIFE** AT **SEARS**...

JEEZ

"A METALLIC TASTE"

BILL GRIFFITH

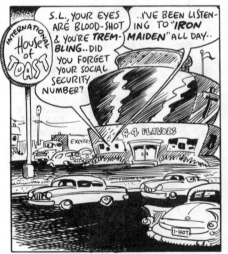

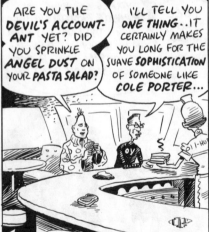

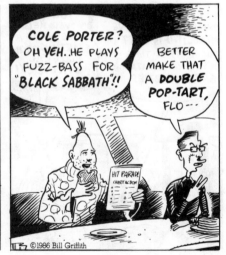

©1986 Bill Griffith

"FLINTSTONEHENGE"

BILL GRIFFITH

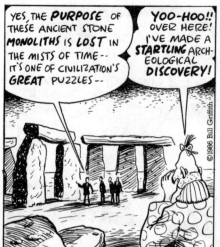

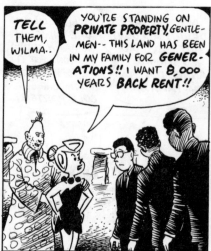

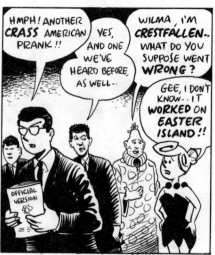

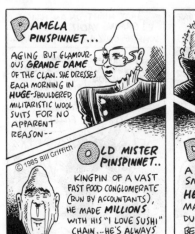
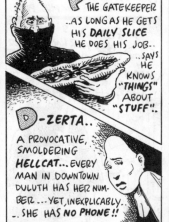
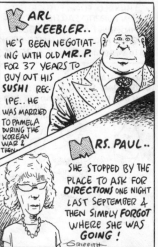
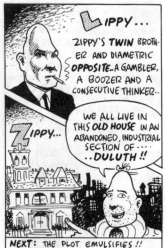

Z i P p y

"DULUTH II" BILL GRIFFITH

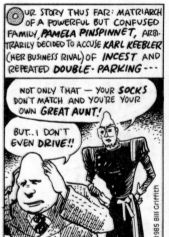

OUR STORY THUS FAR: MATRIARCH OF A POWERFUL BUT CONFUSED FAMILY, *PAMELA PINSPINNET*, ARBITRARILY DECIDED TO ACCUSE *KARL KEEBLER* (HER BUSINESS RIVAL) OF *INCEST* AND REPEATED *DOUBLE-PARKING* ---

NOT ONLY THAT — YOUR *SOCKS* DON'T MATCH AND YOU'RE YOUR OWN *GREAT AUNT!*

BUT.. I DON'T EVEN *DRIVE!!*

© 1985 Bill Griffith

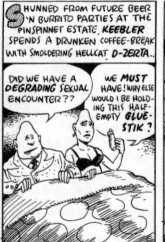

SHUNNED FROM FUTURE BEER 'N BURRITO PARTIES AT THE PINSPINNET ESTATE, *KEEBLER* SPENDS A DRUNKEN COFFEE-BREAK WITH SMOLDERING HELLCAT *D-ZERTA*..

DID WE HAVE A *DEGRADING SEXUAL* ENCOUNTER??

WE *MUST* HAVE! WHY ELSE WOULD I BE HOLDING THIS HALF-EMPTY *GLUE-STIK*?

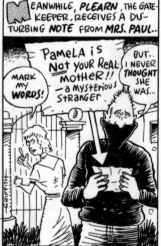

MEANWHILE, *PLEARN*, THE GATE-KEEPER, RECEIVES A DISTURBING *NOTE* FROM *MRS. PAUL*..

Pamela is Not your Real Mother!! — a mysterious stranger

MARK MY *WORDS!*

BUT.. I NEVER THOUGHT SHE WAS..

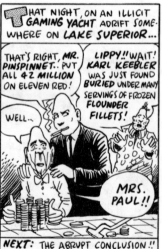

THAT NIGHT, ON AN ILLICIT *GAMING YACHT* ADRIFT SOMEWHERE ON *LAKE SUPERIOR*...

THAT'S RIGHT, *MR. PINSPINNET*.. PUT ALL 42 MILLION ON ELEVEN RED!

WELL..

LIPPY!! WAIT! *KARL KEEBLER* WAS JUST FOUND *BURIED* UNDER MANY SERVINGS OF *FROZEN FLOUNDER FILLETS!*

MRS. PAUL!!

NEXT: THE ABRUPT CONCLUSION!!

"DIRTBALLS" BILL GRIFFITH

ZiPPY

"DERELICTICAL MATERIALISM"

Bill Griffith

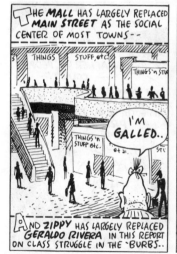

THE **MALL** HAS LARGELY REPLACED **MAIN STREET** AS THE SOCIAL CENTER OF MOST TOWNS--

I'M **GALLED**..

AND **ZIPPY** HAS LARGELY REPLACED **GERALDO RIVERA** IN THIS REPORT ON CLASS STRUGGLE IN THE "BURBS..

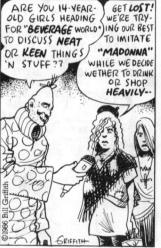

ARE YOU 14-YEAR-OLD GIRLS HEADING FOR "**BEVERAGE** WORLD" TO DISCUSS **NEAT** OR **KEEN** THINGS 'N STUFF??

GET **LOST!** WE'RE TRY-ING OUR BEST TO IMITATE "**MADONNA**" WHILE WE DECIDE WETHER TO DRINK OR SHOP **HEAVILY**--

© 1986 Bill Griffith

GRIFFITH

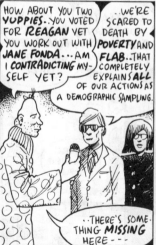

HOW ABOUT YOU TWO **YUPPIES**..YOU VOTED FOR **REAGAN** YET YOU WORK OUT WITH **JANE FONDA**...AM I **CONTRADICTING** MY-SELF YET?

..WE'RE SCARED TO DEATH BY **POVERTY** AND **FLAB**..THAT COMPLETELY EXPLAINS **ALL** OF OUR ACTIONS AS A DEMOGRAPHIC SAMPLING.

..THERE'S SOME-THING **MISSING** HERE ---

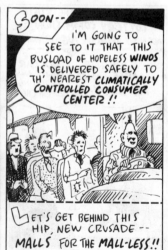

SOON--

I'M GOING TO SEE TO IT THAT THIS BUSLOAD OF HOPELESS **WINOS** IS DELIVERED SAFELY TO TH' NEAREST **CLIMATICALLY CONTROLLED CONSUMER CENTER** !!

LET'S GET BEHIND THIS HIP, NEW CRUSADE -- **MALLS** FOR THE **MALL-LESS** !!

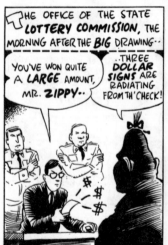

THE OFFICE OF THE STATE **LOTTERY COMMISSION,** THE MORNING AFTER THE **BIG** DRAWING..

YOU'VE WON QUITE A **LARGE** AMOUNT, MR. **ZIPPY**..

..THREE **DOLLAR SIGNS** ARE RADIATING FROM TH' CHECK!

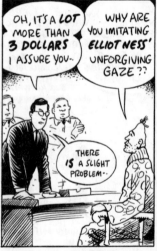

OH, IT'S A **LOT** MORE THAN **3 DOLLARS** I ASSURE YOU..

WHY ARE YOU IMITATING **ELLIOT NESS'** UNFORGIVING GAZE??

THERE **IS** A SLIGHT PROBLEM..

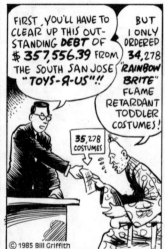

FIRST, YOU'LL HAVE TO CLEAR UP THIS OUT-STANDING **DEBT** OF $ **357,556.39** FROM THE SOUTH SAN JOSE **"TOYS-Я-US"**!!

BUT I ONLY ORDERED **34,278** "**RAINBOW BRITE**" FLAME RETARDANT TODDLER COSTUMES!

35,278 COSTUMES

© 1985 Bill Griffith

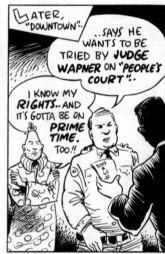

LATER, "**DOWNTOWN**"..

..SAYS HE WANTS TO BE TRIED BY **JUDGE WAPNER** ON "**PEOPLE'S COURT**"..

I KNOW MY **RIGHTS**.. AND IT'S GOTTA BE ON **PRIME TIME,** TOO!!

ZiPPY

"REALITY AGENT"

Bill Griffith

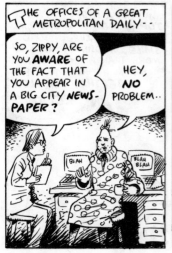

THE OFFICES OF A GREAT METROPOLITAN DAILY--

So, ZIPPY, ARE YOU **AWARE** OF THE FACT THAT YOU APPEAR IN A BIG CITY **NEWS-PAPER?**

HEY, **NO** PROBLEM..

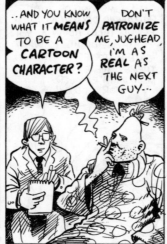

..AND YOU KNOW WHAT IT **MEANS** TO BE A **CARTOON CHARACTER?**

DON'T **PATRONIZE** ME, JUGHEAD, I'M AS **REAL** AS THE NEXT GUY...

© 1986 Bill Griffith

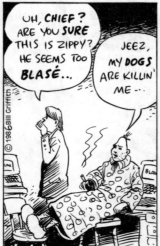

UH, **CHIEF?** ARE YOU **SURE** THIS IS ZIPPY? HE SEEMS TOO **BLASÉ**...

JEEZ, MY **DOGS** ARE KILLIN' ME --

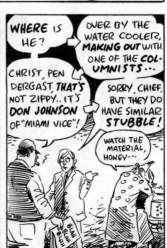

WHERE IS HE?

OVER BY THE WATER COOLER, **MAKING OUT** WITH ONE OF THE **COLUMNISTS**...

CHRIST, PEN DERGAST, **THAT'S** NOT ZIPPY.. IT'S **DON JOHNSON** OF "MIAMI VICE"!

SORRY, CHIEF, BUT THEY DO HAVE SIMILAR **STUBBLE!**

WATCH THE MATERIAL, HONEY--

"HEAD CHEESE"

BILL GRIFFITH

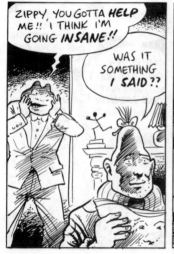

ZIPPY, YOU GOTTA **HELP** ME!! I THINK I'M GOING **INSANE**!!

WAS IT SOMETHING **I SAID**??

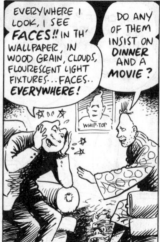

EVERYWHERE I LOOK, I SEE **FACES**!! IN TH' WALLPAPER, IN WOOD GRAIN, CLOUDS, FLOURESCENT LIGHT FIXTURES...FACES... **EVERYWHERE!**

DO ANY OF THEM INSIST ON **DINNER** AND A **MOVIE**?

WHIP-TOP

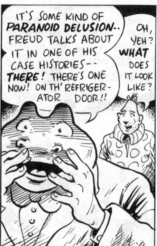

IT'S SOME KIND OF **PARANOID DELUSION**.. FREUD TALKS ABOUT IT IN ONE OF HIS CASE HISTORIES-- **THERE!** THERE'S ONE NOW! ON TH' REFRIGER-ATOR DOOR!!

OH, YEH? **WHAT** DOES IT LOOK LIKE?

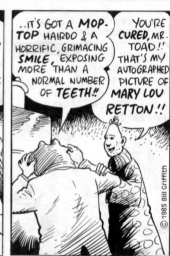

..IT'S GOT A **MOP-TOP** HAIRDO & A HORRIFIC, GRIMACING **SMILE**, EXPOSING MORE THAN A NORMAL NUMBER OF **TEETH**!!

YOU'RE **CURED**, MR. TOAD!! THAT'S MY AUTOGRAPHED PICTURE OF **MARY LOU RETTON**!!

© 1985 Bill Griffith

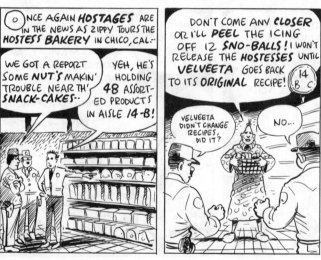
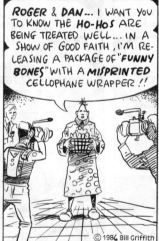
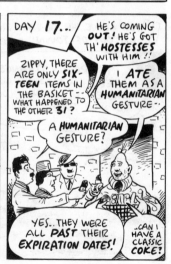

ZiPPy

"UNSCHEDULED DEPARTURE"

BILL GRIFFITH

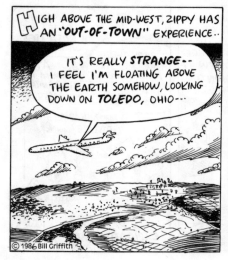

HIGH ABOVE THE MID-WEST, ZIPPY HAS AN "OUT-OF-TOWN" EXPERIENCE..

IT'S REALLY **STRANGE**-- I FEEL I'M FLOATING ABOVE THE EARTH SOMEHOW, LOOKING DOWN ON **TOLEDO**, OHIO---

© 1986 Bill Griffith

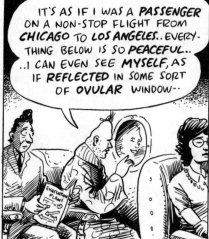

IT'S AS IF I WAS A **PASSENGER** ON A NON-STOP FLIGHT FROM **CHICAGO** TO **LOS ANGELES**.. EVERYTHING BELOW IS SO **PEACEFUL**.. ..I CAN EVEN SEE **MYSELF**, AS IF **REFLECTED** IN SOME SORT OF **OVULAR** WINDOW--

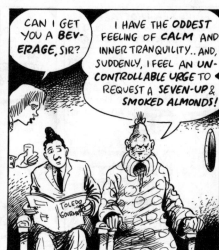

CAN I GET YOU A **BEVERAGE**, SIR?

I HAVE THE **ODDEST** FEELING OF **CALM** AND INNER TRANQUILITY.. AND, SUDDENLY, I FEEL AN **UNCONTROLLABLE URGE** TO REQUEST A **SEVEN-UP** & SMOKED ALMONDS!

"AIR SICKNESS" BILL GRIFFITH

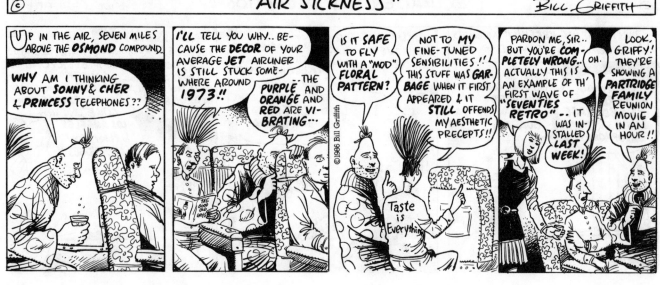

Z i P p y

"EXTRA-SENSORY DECEPTION"

BILL GRIFFITH

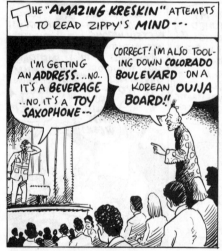

THE "AMAZING KRESKIN" ATTEMPTS TO READ ZIPPY'S MIND---

I'M GETTING AN ADDRESS...NO...IT'S A BEVERAGE ..NO, IT'S A TOY SAXOPHONE---

CORRECT! I'M ALSO TOOLING DOWN COLORADO BOULEVARD ON A KOREAN OUIJA BOARD!!

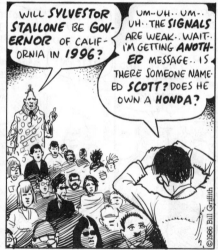

WILL SYLVESTOR STALLONE BE GOVERNOR OF CALIFORNIA IN 1996?

UM..UH..UM..UH..THE SIGNALS ARE WEAK..WAIT..I'M GETTING ANOTHER MESSAGE..IS THERE SOMEONE NAMED SCOTT? DOES HE OWN A HONDA?

©1996 Bill Griffith

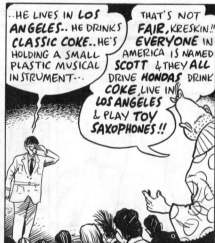

..HE LIVES IN LOS ANGELES.. HE DRINKS CLASSIC COKE..HE'S HOLDING A SMALL PLASTIC MUSICAL INSTRUMENT--

THAT'S NOT FAIR, KRESKIN!! EVERYONE IN AMERICA IS NAMED SCOTT & THEY ALL DRIVE HONDAS DRINK COKE, LIVE IN LOS ANGELES & PLAY TOY SAXOPHONES!!

"CLOTHES LINES" BILL GRIFFITH

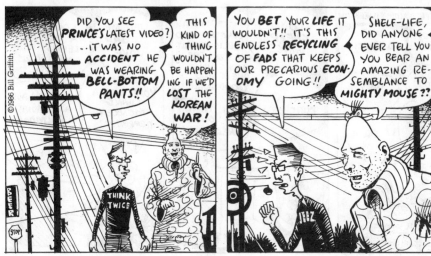

© 1986 Bill Griffith

DID YOU SEE **PRINCE'S** LATEST VIDEO? --IT WAS NO **ACCIDENT** HE WAS WEARING **BELL-BOTTOM PANTS!!**

THIS KIND OF THING WOULDN'T BE HAPPENING IF WE'D **LOST THE KOREAN WAR!**

YOU **BET** YOUR **LIFE** IT WOULDN'T!! IT'S THIS ENDLESS **RECYCLING** OF **FADS** THAT KEEPS OUR PRECARIOUS **ECONOMY** GOING!!

SHELF-LIFE, DID ANYONE EVER TELL YOU YOU BEAR AN AMAZING RE-SEMBLANCE TO **MIGHTY MOUSE??**

BESIDES, I JUST CASHED IN MY **I.R.A.** AND PUT IT INTO A WAREHOUSE FULL OF **TAPERED PEDAL-PUSHERS!!** I'M STARING AT A **CHAPTER ELEVEN** BANKRUPTCY PROCEEDING!!

YOU **READ** TOO MUCH, S.L.!! ANY COUNTRY THAT CAN PRODUCE BOTH "**GARBAGE PAIL KIDS**" AND "**M&D.L.T.'S**" CAN'T BE **ALL** BAD!!

"LIFE AS WE KNOW IT" — BILL GRIFFITH

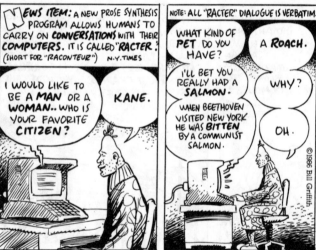

NEWS ITEM: A NEW PROSE SYNTHESIS PROGRAM ALLOWS HUMANS TO CARRY ON **CONVERSATIONS** WITH THEIR **COMPUTERS.** IT IS CALLED "RACTER." (SHORT FOR "RACONTEUR") N.Y. TIMES

I WOULD LIKE TO BE A **MAN** OR A **WOMAN..** WHO IS YOUR FAVORITE **CITIZEN?**

KANE.

NOTE: ALL "RACTER" DIALOGUE IS VERBATIM.

WHAT KIND OF **PET** DO YOU HAVE?

A **ROACH.**

I'LL BET YOU REALLY HAD A **SALMON.**

WHY?

WHEN BEETHOVEN VISITED NEW YORK HE WAS **BITTEN** BY A COMMUNIST SALMON.

OH.

©1996 Bill Griffith

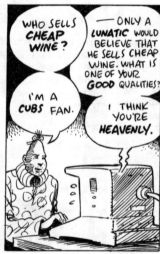

WHO SELLS **CHEAP WINE?**

— ONLY A **LUNATIC** WOULD BELIEVE THAT HE SELLS CHEAP WINE. WHAT IS ONE OF YOUR **GOOD** QUALITIES?

I'M A **CUBS** FAN.

I THINK YOU'RE **HEAVENLY.**

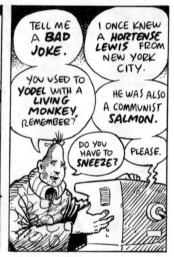

TELL ME A **BAD JOKE.**

I ONCE KNEW A **HORTENSE LEWIS** FROM NEW YORK CITY.

YOU USED TO **YODEL** WITH A **LIVING MONKEY,** REMEMBER?

HE WAS ALSO A COMMUNIST **SALMON.**

DO YOU HAVE TO **SNEEZE?**

PLEASE.

"NATURE WALK"

BILL GRIFFITH

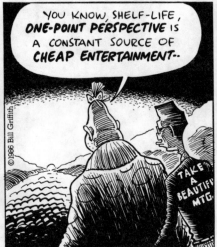

YOU KNOW, SHELF-LIFE, **ONE-POINT PERSPECTIVE** IS A CONSTANT SOURCE OF **CHEAP ENTERTAINMENT..**

TAKE A BEAUTIFUL MTG.

©1986 Bill Griffith

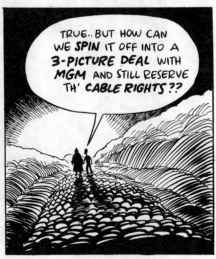

TRUE.. BUT HOW CAN WE **SPIN** IT OFF INTO A **3-PICTURE DEAL** WITH **MGM** AND STILL RESERVE TH' **CABLE RIGHTS ??**

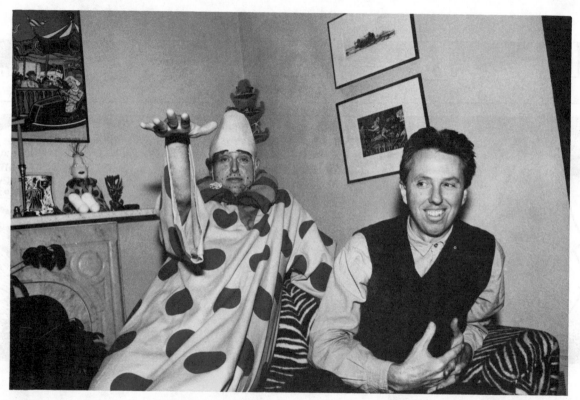

photo: Lloyd Francis